國道地景 × 公共藝術

流動的 THE FLOWING VIEWS
風景

A Road Trip
with Memories of
Time

一趟充滿時代記憶的公路之旅

記憶、故事、藝術，在國道上交織

握著方向盤、搖下車窗，外頭的青山、波浪、稻田、屋舍往後褪去，但車座裡的我們永遠迎著微風，親吻著島嶼的氣味。

高速公路累積一代代臺灣人的成長記憶，在推出 50 年紀念專書之際，我們想記錄的並不只是開山鑿隧道的工程史詩、在第一線鞏固道路安全的無名英雄，更想收錄跨領域人士寶貴的觀點。歷年來無數建築師、藝術家在高速公路周圍地帶及其服務區打造各式各樣的公共藝術，有承傳自義大利文藝復興風骨的大理石雕塑，也有結合童趣與神話意象的工藝遊樂園，而現代建築洗鍊的線條語言，當然也以呼應山稜地景的幾何思維在基地一一重現。

國道公共藝術吸收的養分來自多維度時空的陶冶，創作者用作品表達對城市鄉鎮的關懷，以及對國道未來的想像。在訪談創作理念之餘，交通部高速公路局也想透過文學家、音樂家、導演、懷舊達人之眼，細細訴說自己的相關創作與難忘的國道記憶，每一次回溯軌跡，都像是與霧氣和雨水遊戲的雨刷，畫面愈是清晰，內心也愈是溫熱。

本局目標打造更健全的國道網絡，與多元共融的文化地景，我們謙虛汲取經驗，並積極檢討改進，為的是讓腳下的路往未來下一個百年開去，而這本專書亦是強調公共性、功能性與美學交織的各種可能。

那些不自限、跨出步伐開創世界的人，在高速公路的網絡裡都是閃爍的星。願你我同行，創造國道的經典永恆。

交通部高速公路局局長　趙興華

Interweaving Memories, Stories, and Art on Freeways

Generations of Taiwanese have memories that are connected to freeways, and the purpose of releasing this book that commemorates the 50th anniversary of the bureau involves more than just putting together records of the epic constructions that went into excavating tunnels and building roads and paying homage to all the anonymous heroes at the frontline of ensuring road safety; we also seek to document the valuable viewpoints shared by people of various backgrounds. For years, public artworks of diverse styles have been created around freeways and at service areas by countless architects and artists throughout the years, including marble sculptures that have inherited the Italian renaissance spirit and whimsical art playground with mythical impression. We also see refined modern architectural lines and geometric concepts that echo with the surrounding mountain ridges and landscapes.

Through their creations, the artists' attention and care for each city and town are conveyed, with imaginative visons for the future of our nation's freeways also expressed. In addition to interviewing them about their artworks, The Freeway Bureau under the Ministry of Transportation and Communications also invited people from different specialized fields, including literature, music, cinema, and nostalgia, to recount in details their own creative and unforgettable memories from being on the road.

The mission of our bureau is to provide a network of freeways that's robust and comprehensive and to form a landscape of diverse cultural symbiosis. We climb mountains and go out to the seas to humbly acquire more experiences and to assertively reflect and become better. Our objective is for the roads that we all travel on to be able to take people far and wide in the century to come. This book, therefore, places emphasis on the various possibilities that can come from intertwining publicness, functionality, and aesthetics.

CONT

流動的風景
一趟充滿時代記憶的
公路之旅

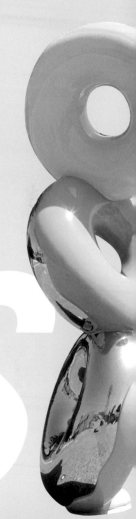

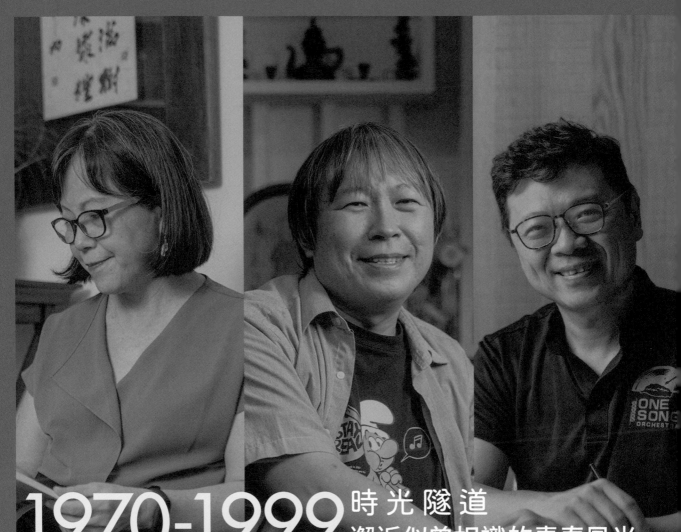

1970-1999 時光隧道
邂逅似曾相識的青春風光

HELLO MY

1970 到 1999 年，是臺灣國道從基礎建設到民生化、科技化以及與藝文接軌的奠基時期。
而公路，也成為不同類型創作者的靈感來源。
讓我們細數光陰，一起回看臺灣社會的過往以及那些與公路相關的深刻回憶。

FRIENDS!

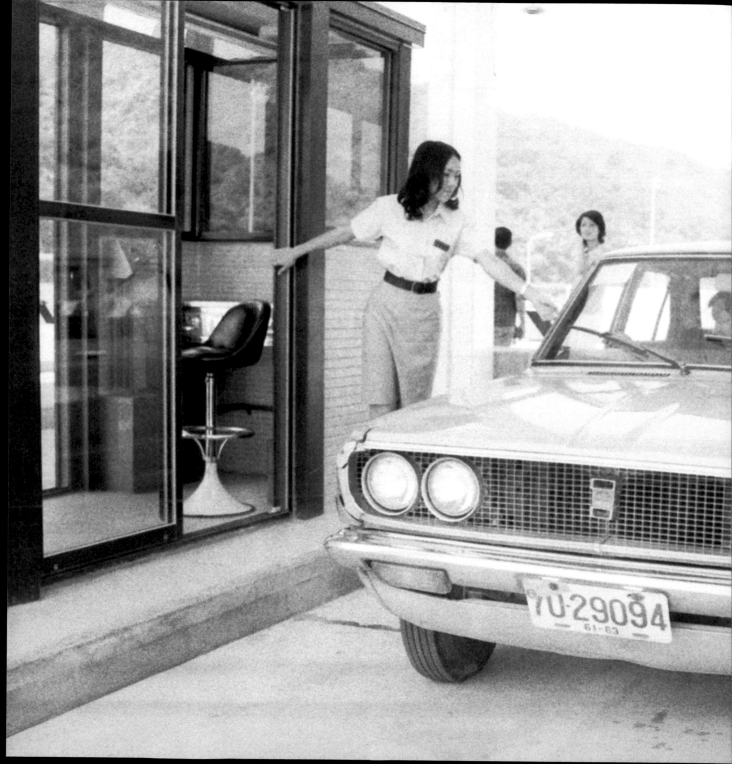

行 路 遠 方

1970 年　「交通部臺灣區高速公路工程局」成立。

1974 年　設立「泰山收費站」，為全臺第一個收費站，並
　　　　　於 7 月開始收費、發行回數票。

1977 年　汐止、楊梅、岡山收費站成立，其中汐止收費站
　　　　　為高速公路最北端之收費站。

1978 年　臺灣區南北高速公路全線通車。高速公路工程局
　　　　　改制為「國道高速公路局」，此外造橋、后里、
　　　　　新營、新市、員林、斗南收費站成立，更啟用「中
　　　　　壢休息站」。

1979 年　湖口、新營、仁德休息站啟用。國道 1 號高速公
　　　　　路命名為「中山高速公路」。

汽車冒煙之必要，廖玉蕙公路奇航

書寫最多汽車主題的文學家廖玉蕙在二二八後的第三年，出生在
臺中市潭子區的鐵道旁，她剛巧趕上三年級的最後一班車，生命
記憶也建構在各種交通網絡上。

撰文／蔡舒涵　攝影／張家瑋　翻譯／廖蕙芬　圖片提供／廖玉蕙

廖玉蕙　臺中市潭子區人，東吳大學中國文學博士。創作以散文為主，曾獲吳三連文學獎、中山文藝獎、吳魯芹散文獎、五四文藝獎章等。著作五十餘冊，編寫多種語文教材。

　　2018 年出版《汽車冒煙之必要：廖玉蕙搭車尋趣散文選》，年屆七旬的文學家回溯車座上的點點滴滴時仍說學逗唱，不時奔放大笑，期間也掩映細膩的溫情。

烏龍夫妻　急驚風遇慢郎中

　　說起丈夫的開車習性，有時真讓廖玉蕙氣得七竅生煙。譬如切換車道時，急性子的她總是見縫插針，而溫文儒雅的丈夫則總是耐心等候。「我覺得這很有婚姻的哲理，反正都會到目的地的啊，表現出他的安穩和擇一固執，選中了那就努力配合吧！」女作家笑開懷。她自稱是重度使用交通工具的行動者，從小學五年級開始搭車通學，30 歲剛拿到駕照時，直覺自己會捅出大簍子，只敢龜速前進。

　　後來，她漸漸掌握手中的方向盤，不僅悟出夫妻相處之道，也看見各種光怪陸離的眾生相。如每逢年節假期，免不得高速公路上的塞車折騰，廖玉蕙咬牙切齒地說，有次從臺中北上中壢，在竹北就尿急得不得了，無奈在快到中壢服務區時，開車的先生竟不小心跟著走捷徑的一輛貨車駛出了服務區，讓她瞬間希望破滅。後來直到新北市五股交流道才找到曙光，膀胱差點憋破了。

在各種車水馬龍的場合中觀察人群，
是廖玉蕙極大的樂趣。

—— 對廖玉蕙而言，「行車」是家
族記憶中非常重要的一環，許
多有趣的兒時回憶或對家人的
思念，都與公路有關聯。

交接地域 跨越心的距離

　　道路上時而對女性駕駛人抱持性別歧視，廖玉蕙則從溫暖的角度切入書寫柔情。例如某次從中壢開車回臺北，順道載兩名女性友人搭便車，途中遇到一位貨車司機對她直閃燈，甚至一路追隨，差點讓她們嚇破膽。後來司機趿著拖鞋、嚼檳榔大步邁來敲車窗，扯著喉嚨勸道：「小姐，妳的後燈不會亮，很危險！在高速公路上會被罰錢。」方知錯怪了對方的好意。

　　高速公路的風景看似千篇一律，敏銳的廖玉蕙依舊從變化的景致中捕捉到幽微的心境轉換。「我的娘家和婆家都在中部，回家的指標是火炎山。每次載我媽媽，一過了光禿禿的火炎山整個陽光普照，她就知道自己的地盤快到了，瞬間燃起氣勢，馬上打開筆記本呼叫賣豬肉的訂貨。所以我很喜歡過火炎山，可以驗證我媽媽的身體狀況。」

沉浸時空 馳騁文學綺想

　　馳騁在無盡延伸的道路上，亦成為文學家的靈感孕育池。她在車上挖掘丈夫的說故事才華，猶記某次先生在高速公路上描述賽珍珠的《母親》故事給家人聽。眼看快到家了，豈知講到生死關頭時竟戛然而止，原來先生紀律嚴明，留下最後三頁沒讀完，只因當時就寢時間到了。文學家好氣又好笑，但不忘稱讚：「在高速公路上發現先生的美好，他原來很會講故事。」

　　廖玉蕙的舊家鄰近縱貫公路和縱貫線鐵路，事實上也來自交通家族。母親 13 歲就考上客運車掌，大哥經營貨運行，二哥做計程車錶，小哥在工地裡開水車，最唯美的描述莫過於當過臺鐵第一屆「觀光號小姐」的三姊。

　　廖玉蕙細數生命中的交通回憶，透過文學形式創造專屬自己的高速公路印象。「作家眼觀四方，耳聽八方，在各種車水馬龍的場合中觀察人群，是我極大的樂趣，而且在交通工具中也尤見臺灣的人情味。」廖玉蕙透過文學形式創造專屬自己的公路印象，從中體悟無憾人生是歲月靜好，沉浸在歡樂中，且一路暢行！

廖玉蕙兒時在潭子的老家屋前，有種一棵鳳凰樹，再過去則是縱貫公路。

The Essential Smoke from the Vehicle and Rose Liao's Spectacular Freeway Trips

An author known for her prolific writings related to cars, Rose Liao was born near a railroad track in the suburban Tanzi District of Taichung three years after the 228 Incident in Taiwan; it was the year 1950, or year 39 on the Republic of China calendar. Born at the beginning of a new decade or the end of another, various transportation networks have seemingly come together to form the memories Rose Liao has from her life.

Written by **Shu-Tien Tsai** Photography by **Chia-Wei Chang** Translation by **Hui-Fen Liao** Images Courtesy of **Rose Liao**

Rose Liao

Rose Liao was born in Tanzi District of Taichung. She specializes in prose writing and has received many literary accolades, including the Wu San-lien Arts Awards, Dr. Sun Yat-Sen Culture and Arts Award; Wu Lu-Chin Prose Award, and the Chinese Literary Medal. Many of her writings are included in textbooks and various literary compilations.

Speaking of her husband's driving habits, Rose Liao can't help but to get a little worked up. For instance, when switching lanes, Rose, who is an impatient person, would cut in at any chance she sees; however, her gentle and unhurried husband would always wait patiently, regardless of how bad the traffic may be. As she became more familiar with being behind the wheel, she has not only gained further insights on her marital relationship but has also seen a wide range of peculiar behaviors from all sorts of people.

Traffic gridlock is always inevitable on freeways during holidays. Rose recalls once they were driving up to Zhongli from Taichung, and she really had to use the restroom half way through the drive. However, when they were about to pull in at a service area, her husband had unintentionally followed a truck and drove out of the service area. "I didn't let my husband live that down for at least three years! I told him he must keep a mind of his own and shouldn't blindly follow other cars!"

Crossing Over the Terrain and the Distance Between Hearts

While driving on the road, female drivers are often confronted with gender-based

discrimination; however, Rose Liao opts to write from a heartwarming perspective to show people's kind and gentle side. She once had two other female friends in her car, and a truck driver kept flashing his headlights at them. The women in the car were quite alarmed by this, but the truck driver kept following them. They later learned that the truck driver just wanted to alert them about a broken backlight. Not only was it dangerous, but they could have also gotten fined. They then realized they had misunderstood his kindness.

Views along a freeway may appear similar at times, but Rose is able to keenly capture subtle emotional shifts and changes alongside fleeting views. "Whenever I have my mom in the car with me, once we see the Fire Mountain, she would know that home was near. She would then call her butcher to order some pork. This is why I enjoy driving by the Fire Mountain, because it's a way to find out the state of my mom's physical wellbeing."

To observe people in various busy situations is something that I quite enjoy.

Cruising in Spatial and Temporal Immersive Literary Wonderland

The writer also discovered her husband's knack for storytelling, while cruising down a freeway. She recalls her husband telling the plots from The Mother by Pearl S. Buck, while they were on the road. When they were almost home, their daughter had begged her father to hurry and finish the story, but he came to a screeching halt in a critical moment of the story, because he hadn't read the last three pages. Dumbfounded but also amused, the writer also praises her husband, "It was on the freeway that I found out my husband is a wonderful storyteller."

Rose Liao carefully recounts the memories she's had in life while being on the road. Through literary writing, she has created freeway imageries that are uniquely her own. "A writer should point her eyes and ears at things happening in all directions. To observe people in various busy situations is something I quite enjoy." By creating her own unique literary expressions of being on the freeway, Rose Liao has also realized that to live life without regrets is to peacefully and calmly spend each day, with smooth roads ahead!

懷舊達人張哲生，往日昰愉悅泉源

燈光昏黃，迴音恍惚，每當駛進隧道，車子彷彿化身時光機，而懷舊達人張哲生也從中發現歷史。名字、紋飾、觀光車，那些被忽視或遺忘的，全成為他的往日探照燈。

撰文／蔡舒湉　攝影／張家瑋　翻譯／廖蕙芬　圖片提供／UDN、Shutterstock

張哲生　1972 年 5 月 16 日誕生，自稱用懷舊展望未來的猛牌大叔，建立台灣第一個專門介紹懷舊卡通的網站「哲生原力」，並出版《飛呀！科學小飛俠》，長存赤子心，傳承六年級生共同的記憶。

身穿藍色小精靈衣服，張哲生像個大孩子般現身西門町的老牌咖啡廳，還未入座便熟門熟路地點了一杯檸檬汁。繁華的城區陪伴這名六年級生一同成長，大環境物換星移地變革，男子卻馬不停蹄地撿拾老舊物事，勤奮而熱烈地還原時代更迭的細節。

以懷舊為名 深探時空印記

「我平常就愛穿有舊卡通圖案的衣服，出門會很開心！」對張哲生而言，懷舊元素是他紓解生活壓力、找回歡樂時光的途徑。當有人質疑一直沉緬過往是故步自封，鴕鳥心態無法面對未來，他卻反其道而行，認為時間不會因為逃避就暫停腳步，人會篩選過去，並從過去經歷呼喚出積極的情緒，這樣的好心情成為他前進的動力，支持他面對現在、展望未來。「我們經歷過許多好好壞壞的事情，聞到熟悉的味道、聆聽老歌，或是欣賞舊照片，心中便湧起懷舊的感覺，回想起與親友共度的美好時光。」

張哲生強調，懷舊效應因人而異，重要的是曾經走過，有經歷過才會懷念，否則就像難以親近的歷史課本。譬如他在分享懷舊卡通時，網友回饋總是出現明顯的年齡層差異；如白光、周璇等流行歌星，也總帶出群星會與繁華的老上海。

功能退場 記憶永不消逝

　　高速公路的景物變遷，亦喚起懷舊達人的諸多聯想。他認為北上的光復隧道與大業隧道，在命名中寄寓昔時的政治理想「光復大業」。身為廣告人的他，特別關注高速公路上的 T Bar 看板。「開高速公路是很沉悶的過程，因為車速很快，廣告不能有複雜內容，必須讓人第一眼就留下印象，內容常常是幾句話接電話號碼，不用花太多時間理解的有趣資訊。」

　　他經歷北二高從無到有的過程，難忘修路期間總得事先確認可行駛路段才上路，而年節大塞車開到天亮才到家的經驗，至今回想仍疲憊不已。為改善車流壅塞，當時政策施行特定時段不收費，愈接近免費時刻，民眾便在收費站旁暫停車輛，形成特殊交通現象。「現在 ETC 取代收費站，少了接觸收費員的機會，走高速公路也少了很多樂趣。」張哲生喜愛接觸人，希望從中看到更多風景、聞到更多味道。當然他亦難忘標榜「高速、冷氣」的中興號，不僅有車掌小姐服務，還提供臥躺和小冰箱等乘車服務。

簡單生活化 推廣有底蘊的美

　　自從科技逐漸取代真人，張哲生感嘆人際互動的風風雨雨幾近銷聲匿跡。他推薦同好上文化部國家文化資料庫和典藏台灣網站挖寶，其中蘊藏大量數位化的老影像、紀錄片和修復的老電影，在在皆是重溫舊夢、認識歷史的珍貴材料。話鋒一轉，他提醒舉辦懷舊展覽，或是規劃歷史街區時，應花費更多行銷費用作宣傳，讓更多人理解老物背後的故事，並用更生活化的方式連結現代人。例如剝皮寮應找回曾在此生活過的人重返舊地，形塑生命力，而非以文創為名進駐缺乏底蘊的內容，使街道流於形式化的模型屋。

　　之於公共藝術，張哲生強調高速公路上任何設施都應以安全為前提，不該出現讓駕駛人分心的事物。而主管單位與媒體也有責任向大眾好好介紹作品的意象內涵，並且清楚宣傳設置位址，增加作品的能見度。「具爭議性的藝術可以討論，但不能只會謾罵。透過扎實的美學教育，我們可以共同提升全民素養。」

張哲生身為廣告人，在高速公路上總是特別關注周遭環境與廣告看板，有著獨到觀察。

懷舊效應因人而異，
重要的是曾經走過，有經歷過才會懷念。

張哲生十分珍惜過往時光，不
論收費站、中興號，有著「懷
舊達人」稱號的他，也熱愛在
社群分享骨董玩具的美好。

Master of Nostalgia Jason Cheung Finds Joy in the Way We Were

Dim lights, dizzying echoes, each drive through a tunnel seemingly transforms the car into a time machine. The journey is where Master of Nostalgia, Jason Cheung, discovers history, with names, patterns, tour buses, and those overlooked or forgotten all turned into searchlights that guide him back in time.

Written by **Shu-Tien Tsai** Photography by **Chia-Wei Chang** Translation by **Hui-Fen Liao** Images Courtesy of **UDN, Shutterstock**

Jason Cheung

Born on May 16th, 1972, Jason Zhang thinks of himself as an uncle from Wanhua, who uses nostalgia to look into the future. Founder of Taiwan's first website dedicated to nostalgic cartoons (www. jasonforce.com), he is also the author of Fly High! G-Force. He seeks to stay a child at heart and to pass down collective memories for those born in the 70s.

Jason Cheung, who was born in the 1970s, grew up in a bustling urban district. As the world around him drastically changed, he has stayed determined to search and collect nostalgic things after taking a dramatic turn in his own life and is dedicated in preserving small details to show how the times have changed.

Jason relieves life's pressures through nostalgia; it is his way of rediscovering joyful times. Some people may think that to linger in the past is to become complacent, but Jason sees it differently. He thinks that time will always progress despite the choice to seek escape. People are able to sort through the past and recall positive emotions from former experiences, which can help us face the present and look into the future.

Memories Will Endure Despite Functional Obsolescence

The shifting sceneries along a freeway always evoke a string of thoughts in the Master of Nostalgia. He recalls driving northbound through the Guangfu Tunnel ("Guangfu" literally means "restoration") and the Daye Tunnel ("Daye" literally means "great cause"), which were named after the political ideal of "restoring the great cause". Jason, who worked professionally in advertising, always

pays extra attention to advertising billboards along freeways. "Driving on a freeway can be quite monotonous, and because the cars are going so fast, the advertisements need to be simple and memorable upon first glance, which is why many billboards just have a few words and a phone number, with interesting information shown that can be quickly grasped."

Jason witnessed the construction of National Freeway No. 3 and recalls having to check on which part of the route was available before hitting the road during the construction. He was once stuck on the road all night during Lunar New Year and didn't get home till dawn; he still vividly remembers how exhausting it was. In order to relieve the traffic gridlock, a policy was then enacted to lift the freeway tolls at certain times. When it was close to a no tolling time slot, people would pull over to wait at the side of the toll booths, which was a unique traffic sight to see. Jason also remembers the Zhongxing Bus, which was promoted as a bus line that offered "high-speed and air conditioning". A staff member would serve drinks on every bus, and the buses also had reclining seats and a small refrigerator.

People are able to sort through the past and recall positive emotions from former experiences

Making Life Simple with Deep-Rooted Aesthetics Promoted

With technology gradually replacing real people, Jason Zhang laments that interpersonal interactions are fading. He recommends visiting the websites of the National Repository of Cultural Heritage and the Taiwan Digitalarchives, which have countless digitized old images, documentaries, and restored old movies and are invaluable treasure troves for history learning.

For public art, Jason speaks from his advertising experience and thinks safety should always come first when installing facilities on a freeway; the drivers should never be distracted. Concepts of the artworks must then be introduced to the public, with the locations clearly stated to increase the artworks' visibility. "We are able to collectively improve people's cultural literacy through a substantial aesthetic education."

開 拓 發 展

1980 年　國道 1 號三重林口段拓寬工程開工。

1981 年　湖口服務區北上啟用。

1982 年　設置新營（北上）服務區駕駛人休憩中心。

1984 年　高公局以任務編組成立中央交通控制中心。泰安服務區內中正紀念公園落成啟用。

1987 年　開放 168 公用電話播放「高速公路路況報導」。

1989 年　「交通部國道南港宜蘭快速公路工程籌備處」成立。全線實施「小型車不找零專用車道」。

上警廣開音樂廳，李哲藝駛出臺灣之聲

全方位古典音樂家李哲藝從 2019 年起於警察廣播電臺主持《警廣音樂廳——臺灣的聲音》節目，他不只從專業角度切入賞析，更帶領樂團主動親近不同群眾，多方闡揚臺灣的音樂文化。

撰文／蔡舒湉　攝影／張家瑋　翻譯／廖蕙芬　圖片提供／李哲藝、Shutterstock

　　現今一機在手即能掌握世界，古典音樂家李哲藝仍然嚮往每一種即時發聲，譬如廣播 DJ 報路況，他認為真人叮嚀既貼心又溫暖，最能深入駕駛朋友的心房，這是手機無法取代的價值。

聆聽入心　各行各業聊音樂

　　李哲藝在《警廣音樂廳——臺灣的聲音》節目貫徹他成立「灣聲樂團」的宗旨——落實臺灣音樂古典化，古典音樂臺灣化。有別於典型的古典樂團，灣聲樂團設計親近一般大眾的音樂會內容，以演奏臺灣的古典音樂為主體，並舉辦系列名人音樂講座。他將這個概念延伸到警廣，邀請胡志強、魏德聖、曲全立、劉軒、向陽……等各行各業代表人物，以輕鬆自然的節奏分享個人故事，談論的議題亦不限於古典音樂，節目廣獲好評。

　　聽警廣報路況和失物協尋可說是臺灣人共同的記憶，除了休閒，亦可提供實際的生活需要。有長年旅居海外的來賓曾遺落物件在計程車上，對於警廣能協助把東西找回來感到喜出望外。不只是音樂，在開車時聆聽談話性節目和新聞動態更有助提振精神，李哲藝說：「我們有很多旅外音樂家回來臺灣實作教學需要北中南跑，開車時間愈長，愈顯出警廣作為陪伴角色的重要性。」

李哲藝　高雄人，現任灣聲樂團音樂總監暨駐團作曲家，第 28 ～ 30 屆傳藝金曲獎音樂總監。樂獲第 23 屆及 27 屆金曲獎最佳作曲人及創作獎。

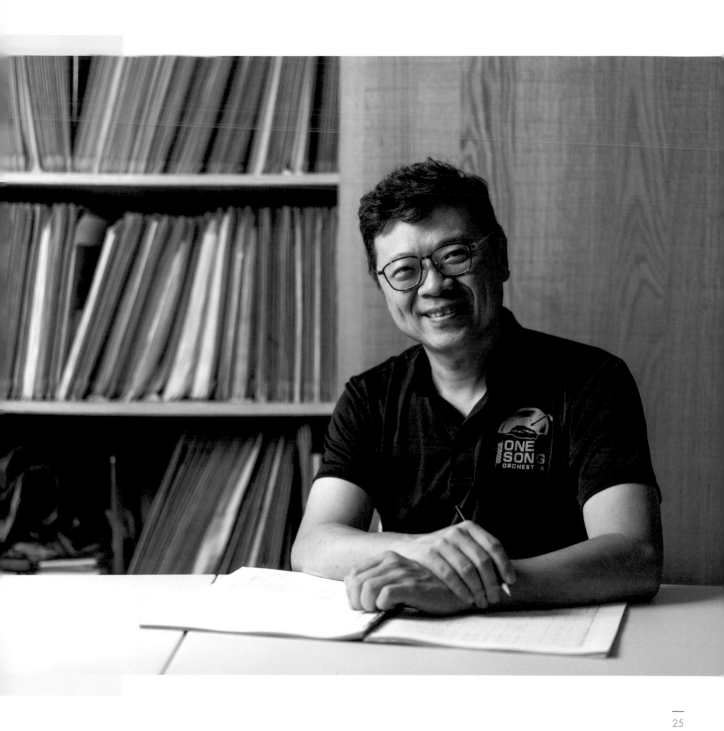

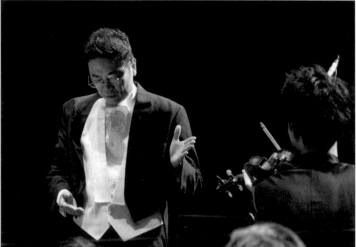

那巨大的凝聚力，有時只要轉開廣播，
你就能邂逅一陣精采。

李哲藝滋養於音樂，並持續透過各種方式讓古典音樂深入民眾的生活中，以旋律演奏出最精采的臺灣樂章。

旋律任我行 行動靈感製造廠

李哲藝演奏豎琴，也是創作者，習慣自駕帶樂器巡演，日常通勤時間是他激發靈感的精華時機。「創作曲子需要很多時間思考結構、素材、手法，開車是最好的時間點，可以專注聽覺解析音樂的細節，我有很多創意都是在開車時發想出來的。」回溯古典音樂家受行路穿梭啟發的傑作，他先是分享西洋老歌〈500 Miles〉，接著推薦史麥塔納（Bedich Smetana）的交響組曲《我的祖國》，和德弗札克的第九號交響曲《新世界》。

他出身高雄，18 歲拿到駕照後，駛遍全臺灣的高速公路，也看遍光怪陸離的交通景象，尤其年節返鄉塞車的煎熬更是不少。有次深夜遇到砂石車翻覆，塞在路上的車輛宛如沉睡的巨龍，排除障礙後，警察一一敲車窗喚醒駕駛者才逐漸恢復通車。他也難忘大學時開著冷氣壞掉的車子放暑假，為抵抗高溫在上路前先到超商買冰前胸後背綁冰塊解暑。

快閃創造 啟動驚喜的風景

音樂家最愛的國道風景一如他繽紛、疼惜臺灣的音樂作品。李哲藝說：「讓我印象深刻的像是田尾，為了催化花期，夜晚燈火通明；五月油桐花開，苗栗路段也美不勝收。」

李哲藝時常帶領樂團舉行快閃表演，他強調，灣聲樂團做行腳的目標就是把音樂帶到民眾身邊，在音樂廳裡的表演難以接觸到不一樣的群眾，藉由快閃活動可創造不同動機，也能考驗音樂家的臨場反應。熱門的快閃秀地點如機場、高速公路服務區等交通過站，而表演曲目不宜太嚴肅，選擇大家耳熟能詳的曲風，更容易和觀眾互動。「Flash mob 的精神就是妙用突發性，在還沒有被管理者驅離之前趕快結束表演，創造預料之外的驚喜。」

灣聲樂團每月定期在誠品音樂廳演奏，亦有新年音樂會在國家音樂廳悠揚開演，用演奏音樂帶著大家遊臺灣，如〈港都夜雨〉、〈丟丟銅仔〉、〈台東調〉……每首曲子都象徵一座城市的生命記憶，那巨大的凝聚力有時只要轉開廣播，你就能邂逅一陣精采。

廣播，是用路人無趣駕車時光的最佳旅伴，李哲藝也透過廣播節目讓音樂更深入人心。

PBS Concert Hall with Sounds of Taiwan Conducted by Che-Yi Lee

A multi-talented classical musician, Che-Yi Lee began hosting the Police Broadcasting Service (PBS) radio program "PBS Concert Hall - The Sounds of Taiwan" in 2019. With Taiwan's musical culture shared through diverse perspectives, Lee shares on the program his professional insights and brings his orchestra closer to the general public.

Written by **Shu-Tien Tsai** Photography by **Chia-Wei Chang** Translation by **Hui-Fen Liao** Images Courtesy of **Che-Yi Lee, Shutterstock**

Che-Yi Lee

From Kaohsiung, Che-Yi Lee currently serves as One Song Orchestra's music director and composer. He was the music director for the 28th ~30th editions of the Golden Melody Awards for Traditional Arts and Music and won Best Composer Award at the 23rd Golden Melody Awards and Best Creation Award at the 27th Golden Melody Awards.

Nowadays, people can explore the world at their fingertips, but classical musician Che-Yi Lee still looks forward to live sounds, such as live traffic reports on the radio. He thinks that the voice of a real person is a lot more heartwarming and relatable for people on the road. This is something that technology can't replace.

Listen to People's Hearts Through Music that is Talked About by Different People

Che-Yi Lee's mission for the One Song Orchestra which he founded is extended to "PBS Concert Hall - The Sounds of Taiwan", which aims for "the classicalization of the music of Taiwan and also to create classical music that is uniquely Taiwanese". Lee designs classical music concerts that are accessible to the general public and also organizes music seminars. His concept is extended to the PBS program, where people from all walks of life are invited to share their personal stories in a natural and relaxed way.

Most Taiwanese people are familiar with PBS's traffic reports and lost and found service. A guest who lives overseas once shared a delightful experience of finding

something that they have left behind on a taxi through the help of PBS. In addition to the music, listening to talk shows or news updates on the radio can also help those behind the wheel to stay awake.

Melodies of Freedom. Finding Inspiration on the Move

Che-Yi Lee is also a harpist and a composer. He enjoys driving his own car while touring and finds inspiration on his daily commute. Lee is from Kaohsiung and after getting his driver's license when he turned 18, he's been driving on freeways traveling all throughout Taiwan, where he has seen all kinds of unusual traffic incidents. He once encountered an overturned gravel truck late at night. The cars stuck on the road looked like a giant sleeping dragon. After the accident was cleared, the police had to knock on the windows of each car to wake up the drivers. Lee also recalls when he was in college, the air condition on his car was broken. He ended up having to tie some ice on his body while driving, in order to combat the smoldering summer heat.

He thinks that the voice of a real person is a lot more heartwarming and relatable for people on the road.
This is something that technology can't replace.

Creating Delightful Musical Surprises During Flash Mob Performances

Che-Yi Lee and his orchestra are often seen in flash mob performances. He strives to bring music closer to people, and picks familiar and easy musical pieces to perform at busy transport hubs, creating bursts of delightful musical performances before the authorities arrive.

One Song Orchestra performs monthly at the Eslite Performance Hall and also presents New Year concerts at the National Concert Hall, performing familiar Taiwanese songs, such as "Night Rain in the Harbor City", "Diu Diu Deng", and "Taitung Tune". Each musical piece symbolizes the memories of each city, and how music's tremendous and exhilarating cohesive energy can be simply experienced when you turn on the radio.

王逸鈴《迎向邊疆公路》，生活的本質是飄移

2017 年短片《迎向邊疆公路》入圍法國坎城影展「電影基石
（Cinéfondation）」競賽單元，導演王逸鈴藉由公路電影形式呈
現東臺灣公路之美，令觀眾沈浸在流動的風景中反思人生況味。

撰文／蔡舒湉　攝影／張家瑋　翻譯／廖蕙芬　圖片提供／公視、Shutterstock

　　或許是習慣片場穿深色衣褲的規矩，導演王逸鈴裹了一身純
黑現身，她的談吐與電影風格相似，節奏緊湊流暢，不時勾勒扣
人心弦的畫面感。問及拍公路電影的原因，她瞬間將場景調度到
異域公路旅行——一個人、一臺露營車，還有無止盡的漫漫長途。

深入生活　捕捉地域底蘊

　　在拍攝《迎向邊疆公路》前，王逸鈴在國外當了一年背包客。
開著露營車，駛過各地的大道小徑，車窗外不斷流逝的風光刺激
她重新思索臺灣公路特色，也才意識到雖然島國不大，但多元景
致足以站上國際舞臺。回臺後，她開拍公路電影，企圖捕捉特有
的臺灣味。「公路電影很吸引我的特質是透過空間的改變跟流動，
表現角色的心境、歷險與情節。空間是無所不在的，所以場景又
可以從道路延伸到邊疆城市。角色可能因為某種原因出發冒險，
一路上內心也要隨之改變、成長。生活的本質是飄移，生命也是
線性的時間軸。」

跳接城鄉　尋找容身之處

　　《迎向邊疆公路》將場景設在臺東至臺北，故事發生在 24 小

王逸鈴　影像工作者，國立臺灣藝術大學電影學系畢業，導演作品入圍過各大國內外影展，包括法國坎城影展電影基石競賽單元、金馬影展、台北電影節等。現為拾影像文化有限公司負責人。

晚上高速公路只看得到光線的狀態，
畫面清晰定格，軌跡稍縱即逝。

王逸鈴將對公路的感受，訴諸
影像，透過鏡頭呈現出臺灣的
公路印象。

時之內，主人翁加明是臺東果農，因祖厝被法拍，被迫把家當搬上小貨車遠走他鄉。被放逐的路上，他遇到越南籍女性阿央，她遭遇了一些麻煩正準備返鄉回越南。失去家的他與準備回家的她像是相依為命，坐在移動的車子裡，共同開展一段未知的旅程。

王逸鈴提及，若公路電影切分自然（原始空間）、小鎮（前現代）、都市（現代）三塊地物，早期公路電影的核心多半表現原始跟現代的對抗。來自都市的角色赴荒野放逐自我，在流浪過程尋找心中的價值，返璞歸真，有回歸空間的意圖。「我從反向讓角色從小鎮回到現代社會尋找容身之處。從臺65線快速公路北上過程，沿途有交流道和高架橋，複雜的道路風景反映角色心境。結局是在都市山上看著遠方的城市與煙火，頭上一架巨大的飛機，象徵壓垮他們的一切。就算遷移了，內心仍感到格格不入。」

手法上，她透過一段反覆跳剪表現時間、空間的演變，藉由速度感表現躁動感。為了充分掌握場景，她早早前往臺東做田野調查。「我跟當地居民、攤販對話，還研究稻田的灌溉方式、作物的生長週期。我不想當觀光客，要真的了解城市狀態才拍，而不是漂亮而已。」

賞味流動 感悟人生風景

她出生新北市東北郊區，沿途風景山河交替的侯牡公路（北37線）有她溫暖的童年回憶，但凡是流動中的風景都令她格外著迷。「速度感很重要。我喜歡晚上高速公路一片漆黑、只看得到光線的狀態，畫面清晰定格，軌跡稍縱即逝。我也喜歡開交流道和高架橋，白天時，光影在大樓表面流動；晚上時，大大小小樓窗有不同色溫，我會想像裡頭有不同人物，這很像社會的縮影。」

多次入圍、榮獲國內外電影獎項，入圍過台北電影節、金馬影展，同時也是女性影展和酷兒影展的常客，王逸鈴說，對一個創作者或導演而言，任務是做好本分，其他讓觀眾評價。任何人都無法代言議題，重要的是，做事前先想清楚可以帶來什麼改變再出發。「我希望有一天，『同志』和『女性』都不再是一個議題。」

對王逸鈴來說，晚上高速公路旁建築物窗戶透著不同色溫，都是激發想像力的時刻。

Yi-Ling Wang's "Towards the Sun", Life is Essentially Ephemeral

Towards the Sun directed by Yi-Ling Wang was selected for the Cannes Film Festival's Cinéfondation category in 2016. The film tells the story of a road trip and shows the beauty along the freeway by Taiwan's eastern coast, with the audience invited to reflect on life while immersed in moving landscapes.

Written by **Shu-Tien Tsai** Photography by **Chia-Wei Chang** Translation by **Hui-Fen Liao** Images Courtesy of **PTS, Shutterstock**

Yi-Ling Wang

Yi-Ling Wang is a filmmaker, whose films have been featured in the Women Make Waves International Film Festival, Golden Harvest Awards, Cannes Film Festival - Cinéfondation (a competition of short films by student filmmakers), Taipei Film Festival, Urban Nomad Film Festival, Taiwan International Queer Film Festival, and others.

Perhaps she's used to wearing dark clothing on film sets, director Yi-Ling Wang showed up at the interview in all black. When asked why did she make a road trip movie, she quickly transported the scene to being on the road, traveling on a seemingly endless journey, in solitude behind the wheel of a camper van.

Before the film, Towards the Sun, Wang was a backpacker around foreign country for over a year. She drove a camper van, and the sceneries fleeting by prompted her to reconsider the unique sights along the freeways in Taiwan. She then realized how vibrant and enchanting the landscapes are in Taiwan, so unique that they should be shared with the world. After returning to Taiwan, Wang began making the road trip movie, with the objective of capturing features that are uniquely Taiwanese.

"I am quite drawn to road trip movies because of the changing and shifting sense of space, and how the characters' inner worlds, the experiences, and the plots are expressed. The sense of space feels ubiquitous, so the scene can extend from the road to the edge of a city. The character, embarking on an adventure due to a particular reason, goes through internal changes and growth while being on the road. Life is essentially ephemeral, and it also unfolds in a linear timeline."

Leaping Between Town and City, Finding a Place of Belonging

Wang divides the road trip movie into three sections: nature (original space), small town (pre-modern), and city (modern). According to her, the focus in the beginning shows a conflict between the original and the modern, with the protagonist from the city venturing into the wild on a self-exile. In the process of wandering, the person looks for what is intrinsically valuable and takes a path that returns to a place of innocence and simplicity.

Wang uses an editing technique that shows repeated and leaping temporal and spatial changes, with pace used to show a sense of restlessness. In order to gain better control over the film locations, she visited Taitung well in advance to do field survey. "I talked to local residents and merchants, studied how the rice paddies are cultivated, and learned about seasonal cycles. I didn't want to be a tourist; I wanted to truly understand the place and didn't want to just make it look pretty."

Cherishing Moving Scenes, Appreciating Life's Landscapes

Wang was born in the suburbs of New Taipei City and has made many fond childhood memories on the area's Provincial Highway 37, where landscapes, mountains, and rivers crisscross. She has always found moving landscapes quite mesmerizing. "That sense of speed is quite important. I am drawn to being on the highway at night, where everything is dark except for the lights. It feels like a clear and still picture, but there is a fleeting trajectory. I also like driving on interchanges and overpasses. During the day, lights and shadows shift on building facades. At night, lights of various degrees of warmth gleam from windows of different sizes and make me wonder about the different people inside. The scene is an encapsulation of society."

> I am drawn to being on the highway at night, where everything is dark except for the lights..

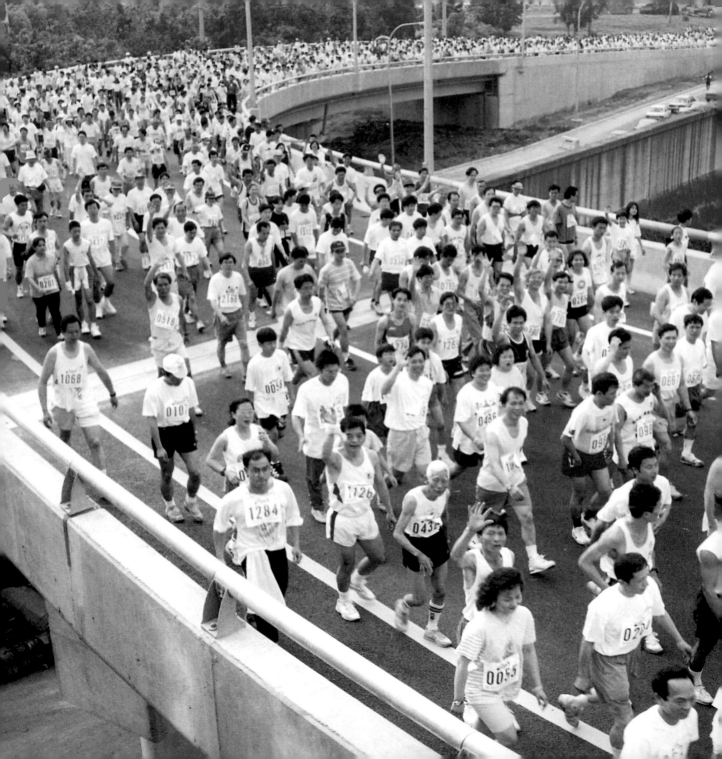

接 軌 未 來

1990 年　王振芳任高公局局長。

1992 年　田徑協會在北二高舉辦史無前例的「1992 台北
　　　　國際國道馬拉松」競賽。

1994 年　實施大客車駕駛及前排乘客需繫安全帶。

1995 年　慶祝高公局成立 25 週年暨汐五高架拓寬工程環
　　　　河北路至五股路段完工，在該路段舉辦「1995
　　　　年國道半程馬拉松賽」。

1996 年　「交通部臺灣區國道高速公路汐止五股段高架拓
　　　　建工程處」改名為「交通部臺灣區國道高速公路
　　　　局拓建工程處」。

1999 年　原休息站及服務區統稱服務區，路側停車場統稱
　　　　休息站。

作家陳幸蕙，馬拉松的人生度量衡

因出身高雄、定居臺北，陳幸蕙時常往返南北高速公路，沿途景致啟發她寫作〈碧沉西瓜〉刻劃西部平原的安寧與豐饒。熱愛跑步的她也曾參與公路馬拉松，從中療癒與進化自我。

撰文／蔡舒湉　攝影／蘇威銘　翻譯／廖蕙芬　圖片提供／陳幸蕙、Shutterstock

「曾經有人問我：陳老師妳都開什麼車？我回答開 BMW，她嚇一跳！事實上，B 是 BIKE（腳踏車）、M 是 METRO（捷運）、W 是 WALK（走路）。我是不開車的人，硬要問，我就說我是開 BMW。」身為作家，陳幸蕙在三年內完成 17 趟馬拉松。筆耕與跑步有相似的孤獨，她也總在每個過程收穫痛快的領悟。

由愛起跑 50 始戰初馬

學生時代痛恨跑步，對跑步的印象停留在折磨體力的懲罰。未料當上作家後，長期寫作生活讓陳幸蕙自覺應平衡動靜，於是先從打羽毛球出發，在球伴經常告假之後，轉向可以單獨進行的運動，套上跑鞋啟動跑者人生。她自嘲是異想天開，才在過了 50 歲的年紀開始參加路跑比賽。她的「初馬」是具指標性意義的「太魯閣馬拉松」，賽程沿途景觀秀麗，還有一段漫長的上坡令她特別難忘，爬坡時氣喘如牛，折返時輕若飛燕。

陳幸蕙每週固定跑兩至三次，以每個月增加兩公里的進度，逐漸從 100、200 公尺，增加至九公里，自忖「好像沒問題」後，再訓練至全馬公里數。「練全馬時，我曾經從新店跑到淡水八里。只要有動機、意志力，按部就班就能達成目標。」

陳幸蕙　自由的文學人，以研究余光中聞名，2008 年參加太魯閣公路馬拉松，認為人生諸事都必須在持續中才能顯出意義，於情感、於寫作都是如此。

以馬拉松為喻 鍛鍊生命

　　陳幸蕙跑步時不帶手機、耳機，認為太專注於網路或音樂會忽略周邊環境變化，她說：「我會一邊構思正在書寫的作品，在腦海裡思考怎麼修改潤飾，或是訂定未來的寫作計畫。」她總在跑步時把日文背誦得滾瓜爛熟，思緒糾結時，跑步更是她舒壓的最佳管道。「母親剛過世時，我很難過，覺得非得出去跑不可。跑步時可以梳理內在混亂的情緒，是療癒的過程。」

　　後來因左足踝開刀，陳幸蕙有半年時間得拄拐杖、坐輪椅，行動不便刺激她重新反思自己為何而跑？此後，她將道路上的比賽拉回生活，「我仍參與我的時光馬拉松、歲月馬拉松，把堅持的概念延伸、放大、精神化，如寫作是文學馬拉松，與先生是愛情馬拉松，與兒女是親子馬拉松，從中形塑人生意識，內在會比較強壯。」

眷戀窗外 銘記碧沉西瓜

　　因婆家位於美濃，陳幸蕙剛結婚時常從臺北坐國光號走高速公路南下高雄，她曾撰寫散文〈碧沉西瓜〉描摹車窗外遞嬗的田園風光，也因此機緣與年輕世代保有文學上的連結。「我最喜歡縱貫臺灣南北的國道 1 號和國道 3 號，尤其是嘉南平原一望無際、綿延到天際的稻田，這段具臺灣代表性的田園美景觸發我對島嶼的愛。」為了品嘗特產西螺醬油，她總在嘉義的服務區停留採購這款懷舊的古早味。她印象深刻的還有國道 5 號，穿越雪隧後湛藍的太平洋與遠方的龜山島便浮現眼前，「我很喜歡漸漸進入宜蘭的路線，一大片的蘭陽平原帶有濕潤的綠，特別養眼也養心。」

　　住新店的她，日常喜愛沿著水道慢跑欣賞河流景致，至今維持一個禮拜跑 30 公里，也習慣從馬拉松角度衡量距離感。陳幸蕙說：「我現在正在寫的書就叫《我的馬拉松故事》，描述一度痛恨跑步的女孩，如何成為樂在跑步的女性。」她歸結跑步的心路歷程，並從中領悟：「你堅持的不是地理上的距離，而是時光。不預設終點，就能持續跑下去。」

家鄉美濃一望無際的田園美景，以及穿過雪隧映入眼簾的龜山島，都是陳幸蕙難忘的國道美景。

你堅持的不是地理上的距離,而是時光。不預設終點,就能持續跑下去。

對陳幸蕙而言,跑步是鍛鍊,更是人生意識的形塑,在每一步踏出的步伐中,梳理、療癒、再出發。

Prose Writer Hsing-Hui Chen Learns About Life from Marathons

Born in Kaohsiung and lives in Taipei, Hsing-Hui Chen is no stranger to the freeways that connects southern and northern Taiwan. The sceneries along the route had inspired her to write Emerald Green Watermelons, which depicts the serenity and richness of Taiwan's western plains. An avid runner, Chen has run in freeway marathons, which she finds therapeutic and makes her a better person.

Written by **Shu-Tien Tsai**　Photography by **Wel-Ming Su**　Translation by **Hui-Fen Liao**　Images Courtesy of **Hsing-Hui Chen, Shutterstock**

Hsing-Hui Chen

A free-spirited writer, Hsing-Hui Chen is well known for her studies on Taiwanese writer, Kwang-Chung Yu. She ran in the Taroko Gorge Marathon in 2008 and believes that the meaning of everything in life can only be realized through perseverance. This is also true for relationships and writing.

Author Hsing-Hui Chen has completed 17 marathons in three years. She finds writing and running share the same sense of solitude, and she is always able to gain exhilarating insights from each experience.

She recalls running was a form of corporeal punishment when she was a student. After becoming a writer and having to sit and write for prolonged periods of time, she needed to find a balance between being still and being active. She began with playing badminton and later started running. The iconic "Taroko Gorge Marathon" was her first marathon. The competition takes place along breathtaking views, and she recalls vividly how difficult it was to go uphill but felt light as a bird on the way down. "I once ran from Hsintien to Tanshui when I was training for a full marathon. As long as you have the motivation and willpower, you can achieve your goals, step by step."

Life's Trainings with Marathon as Metaphor

Hsing-Hui Chen doesn't carry her phone or use headphones when she's running. She contemplates over her writing while she runs, as she thinks about how to

improve her work or plans out future writing projects. When her thoughts get muddled, she finds running to be the best way for relieving stress. It is a therapeutic process that helps her to organize her disorderly emotions.

She had to rely on a walking stick or wheelchair for six months after having surgery on her left ankle. The physical restrictions prompted her to reflect on why does she run. She later shifted her focus from competing on the road back to her life. "I am still actively running in the marathon of time. I've extended, augmented, and spiritualized my determination. I see writing as a literary marathon, my relationship with my husband as a love marathon, and my children are a family marathon. I've learned to shape my awareness for life from them, which has helped to make me stronger inside."

Enchanting Window Views, Memorable Emerald Green Watermelons

Her in-laws live in Meinong, and as a newlywed, Chen often took the bus to travel on the freeway from Taipei to southern Taiwan. Her prose, Emerald Green Watermelons, illustrates the rural sceneries she saw outside the window. She would always stop at the Chiayi Service Area to buy Si Lou Soy Sauce, a regional specialty known for its nostalgic flavors. The view of the cobalt blue Pacific Ocean and the Turtle Island at a distance when emerging from the Hsuehshan Tunnel on the National Freeway No. 5 is a memorable sight. The lusciously green Lanyang Plain is also soothing for the eyes and the heart.

She enjoys jogging along the waterway in her city, Hsintien, where she runs and appreciates the view of the river. Till this day, she still runs 30 kilometers a week. Reflecting on her journey as runner, she shares the insights she has gained and says, "The geographical distance is not what you are pursuing after. It is time. Without setting an end point, you can keep running."

> The geographical distance is not what you are pursuing after. It is time.
> Without setting an end point, you can keep running.

臺灣公路推手，歐晉德的交通藍圖

中山高速公路是歐晉德留學歸國後投入的第一個工作，也是十大建設最成功的計畫。從公路到高鐵，他以工程學者的胸襟檢討技術、守護環境，持續檢討未來的交通大計。

撰文／蔡舒湉　攝影／張家瑋　翻譯／廖蕙芬　圖片提供／齊柏林 空中攝影、中央社

每逢上電視闡述交通理念，接掌過公路、高鐵等重大基礎建設的歐晉德總是強調：「路，一定要設法銜接。」他妙喻：「國土如同人體，高速公路就像主動脈。血液無法流通的地方，器官就會壞死。路不能一直擴寬，而是要有更細微的支線分散輸送。」

建設路網　公路與鐵路相輔相成

1973 年，歐晉德以臺灣首位大地工程博士身分從美國返鄉，躬逢十大建設的起點。他從中山高速公路開始，陸續參與臺北鐵路地下化、北宜高速公路的興建與南迴鐵路等計畫，並主導興建北部第二高速公路。「國家給我機會做公路系統，我有責任畫出未來 50 年的高速公路，要釐清服務內容，維護環境，並注重均衡性，為此我做 20 年局長（交通部國道新建工程局首任局長）不調動都沒關係！」

1969 年，臺灣平均國民所得只有 300 多塊美金，汽車共八萬多輛，縱使把全臺車子都開上四車道的高速公路，也只能從臺北排到臺中，從必要性、技術性探討，大家對建造中山高的政策議論紛紛。但不到十年，車輛與國民所得都增加五倍，為避免公路癱瘓的窘境，政策持續推動建設計畫。

歐晉德　曾任交通部國道新建工程局首任局長、行政院公共工程委員會主任委員、臺北市副市長、臺北智慧卡票證公司董事長、臺灣高速鐵路公司執行長、董事長等。現任天主教善牧基金會董事長、看見‧齊柏林基金會董事長。

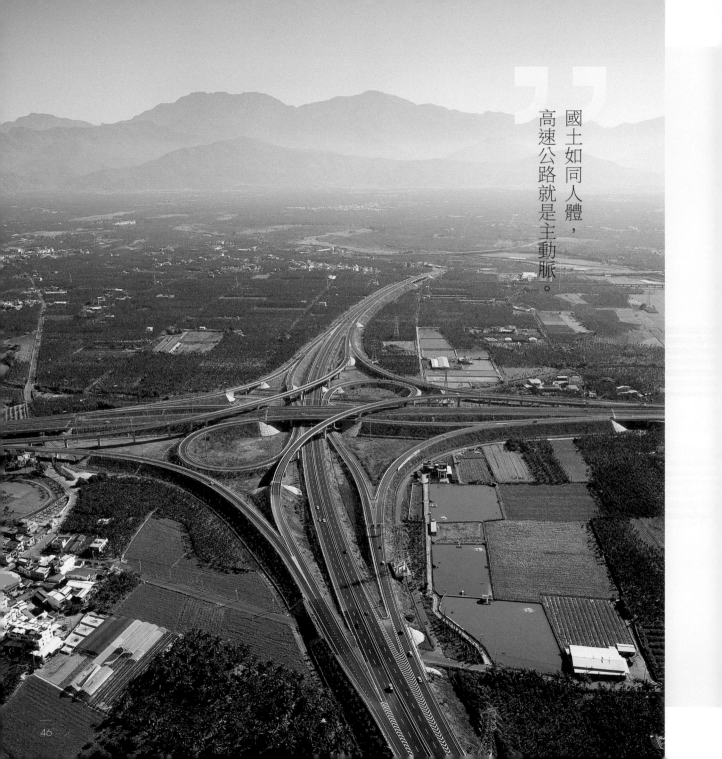

國土如同人體，高速公路就是主動脈。

46

當時西部走廊已有臺鐵和第一條高速公路，面臨經費困難時，他剖析公路比高鐵的運量更大、占地面積更多，也更容易維運，一度提議高速公路民營化，把經費讓給高鐵。後來兩項建設都付諸實行，也印證完成公路網絡的必要性。

空拍鑑今 依循自然做大地建設

與此同時，歐晉德錄用了日後臺灣最出名的空拍攝影家——齊柏林。他的初衷是從工程目的出發，留下跨越時空的影像證據（例如研究地層下陷），而非捕捉唯美畫面。「做工程要負責的，一張照片勝過千言萬語，一定要同角度、同高度，向後人證明 20 年後做對和做錯什麼。」齊柏林最初到國工局應徵 22k 當工程師，歐晉德隨口問了：「興趣是什麼？」青年回答照相，正巧與他的構想不謀而合。空拍工作是每月固定時間飛一個鐘頭，這一拍也拍出了國民的環境意識。

為新加坡、印尼設計高速公路後，歐晉德回臺規劃北二高，並且引入新工法，提升建造標準。「臺灣多山，必須突破挖隧道跟造橋的技術，能達到安全、省錢和保護環境，就是極大的貢獻。」北二高實現 1,762 公尺的福德隧道，北宜高速公路又完成 12.9 公里的雪山隧道，創下臺灣最長公路隧道紀錄，而不破壞原生環境的原則，「遇水架橋、逢山開洞」，更建構出秀麗的景觀公路。

自然為美 景觀就是最好的藝術

「如果設計可以融合景觀，造就自然的美，何須刻意創造藝術？」歐晉德主張，建築是藝術的技術性呈現，建築工程本身就該是藝術。

身為工程師，歐晉德期待未來臺灣高速公路能研發更完美的橋梁建造技術，維養好邊坡植栽景觀，並且完善道路銜接系統。「我腦中想像，在山谷裡頭有一座 200 公尺高的橋墩，跨徑是一至二公里，從一個山頭到另一個山頭，能在雲霧縹緲中看見臺灣的美，又不破壞地形環境，這是未來工程師可以擁抱的夢想。」

歐晉德身為工程師，期望未來臺灣高速公路能研發出更完美的橋梁建造技術。

A Driving Force Behind Taiwan's Freeways, Chin-Der Ou and His Transportation Blueprint

The first job that Chin-Der Ou worked on after returning to Taiwan from studying abroad was the Sun Yat-sen Freeway, which is considered the most successful in Taiwan's Ten Major Construction Projects. From freeways to the high-speed rail, Chin-Der Ou continues to apply his expertise as an engineer and an academic to conduct technological reviews, to protect the environment, and to assess major transportation projects in the future.

Written by **Shu-Tien Tsai** Photography by **Chia-Wei Chang** Translation by **Hui-Fen Liao** Images Courtesy of **Chi Po-lin Foundation, CNA News**

Chin-Der Ou

Bureau under the Ministry of Transportation and Communications, and also served as chairman of the Executive Yuan's Public Construction Commission; deputy mayor of Taipei City; CEO and Chairman of Taiwan High Speed Rail Corporation (THSRC). He currently serves as chairman of the Good Shepherd Social Welfare Foundation and the Chi Po-lin Foundation.

Chin-Der Ou often appears on television to share his thoughts on transportation, and as someone who has worked on major infrastructure projects, such as freeways and the high-speed rail, he cleverly explains, "The land of a nation is like a human body, and the freeways are the arteries, and in places where blood flow can get obstructed, organs would fail. Roads can't be incessantly expanded, and there needs to be more intricate ways to branch out and decentralize when it comes to transportation."

Building Network of Roads with Complementary Freeways and Railways

Chin-Der Ou returned to Taiwan from the United States in 1973, after becoming the first person in Taiwan who holds a doctoral degree in Geotechnical engineering. It was a time when Taiwan was launching the Ten Major Construction Projects. He began by working on the Sun Yat-sen Freeway and later took part in other projects, including the Taipei Underground Railway Project, Taipei-Yilan Freeway, and South-Link Line, and he also directed the construction of National Freeway No. 3.

The national income per capita in Taiwan in the year 1969 was only US$300,

and there were around 80,000 cars. If all of those cars in Taiwan would go on a four-lane national freeway, the line would begin in Taipei and soon end in Taichung, which made the necessity and the technical demands of the Sun Yat-sen Freeway quite debatable. However, in less than a decade, the number of cars and the per capita income in Taiwan quintupled, and in order to prevent traffic congestion on freeways, policies were imposed for the infrastructure projects to be carried on.

Guided by Aerial Photography with Nature Respected in Land Development

Chin-Der Ou also commissioned who would later become Taiwan's most renowned aerial photographer, Po-Lin Chi, with the initial intention of documenting the construction and to preserve visual evidence (such as land subsidence for research purposes); capturing beautiful images wasn't a priority. Po-Lin Chi had applied for an engineering position at the Taiwan Area National Expressway Engineering Bureau, where he was asked by Chin-Der Ou about his hobby. "Photography" was the then young Po-Lin Chi's reply, which coincidentally aligned with Ou's plan. The task of capturing aerial images later opened up Taiwanese people's awareness for the environment.

Beauty in Nature, Extraordinary Art in Landscape

"If landscape can be incorporated in a design, with nature's beauty enhanced, would there then be a need

> The land of a nation is like a human body, and the freeways are the arteries.

to deliberately make art?" Chin-Der Ou asserts that architecture is the technical presentation of art, and architectural engineering should be an art form.

Chin-Der Ou hopes that the bridge construction technologies used on freeways and also the road connection system in Taiwan can be perfected in the future, and the vegetation and landscaping along the routes can be well maintained. "I envision a 200-meter high bridge in a valley gorge. It spans 1 to 2 kilometers from a mountain to another, where the beauty of Taiwan can be seen through drifting clouds and mists, and the geological environment is protected.This is a dream that engineer can nourish in the future."

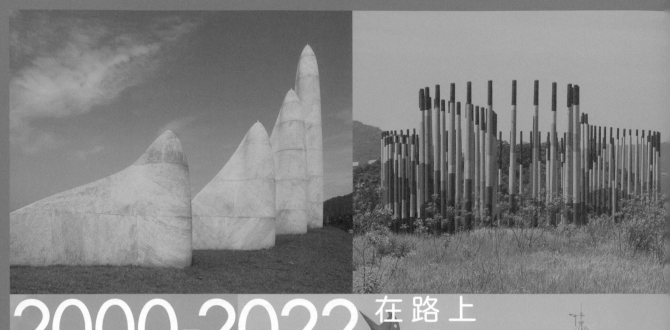

2000-2022 在路上
相遇的每一種美麗

STORIES

時間來到 2000 到 2021 年，是公共藝術在臺灣萌芽、茁壯、百花齊放的時期，高速公路亦透過藝術優化地景。
從早先的景觀紀念意義，到融合地景與休閒需求的複合式設計，進而衍生出在地化的互動作品，賦予人文與傳承價值。
讓我們隨著十組藝術家的目光，重新以不同視角解讀這片土地的文化肌理，並讓公共藝術作品，有更多對話的空間。

& ARTISTS

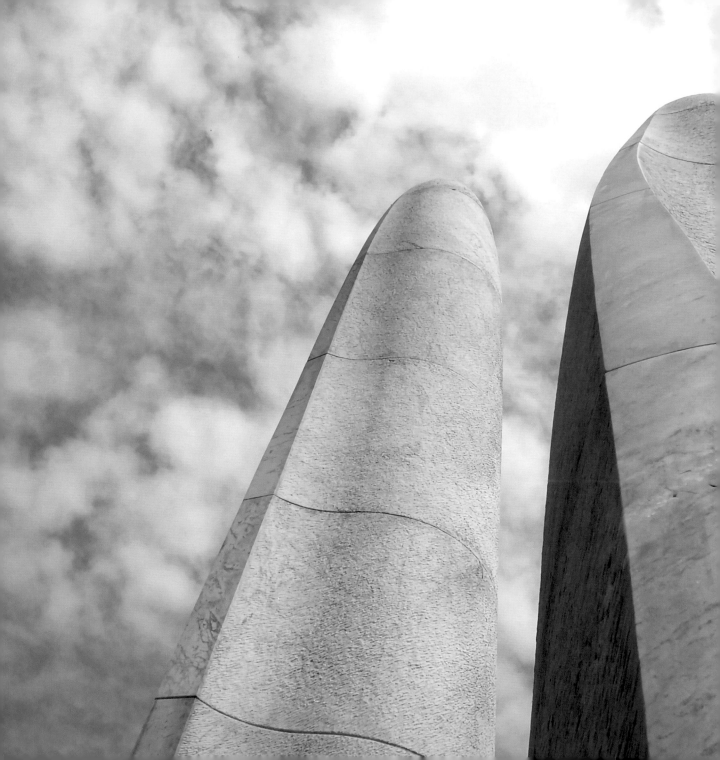

地景與美

當公共藝術在高速公路初試啼聲，會迸發出怎樣的火花呢？不論是以石材線條結構勾勒出地景風貌、考量用路人視角創造出來的行車動畫藝術、將設計活躍於國道以訴說川流不息的車潮，或是以豐富色彩與弧線呈現的時代精神。藝術與高速公路的相遇從此開始⋯⋯

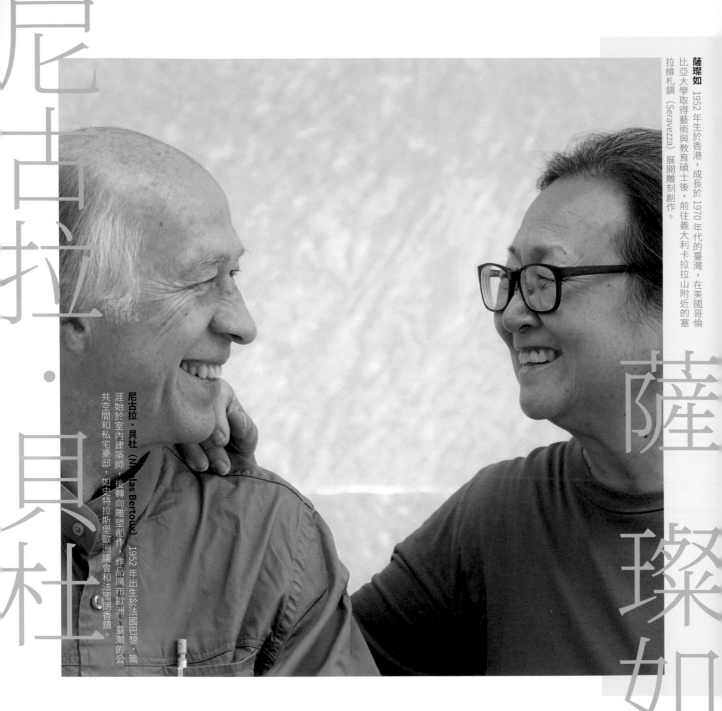

薩璨如 1952 年生於香港，成長於 1970 年代的臺灣，在美國哥倫比亞大學取得藝術與教育碩士後，前往義大利卡拉拉山附近的塞拉維札鎮 (Seravezza) 展開雕刻創作。

尼古拉・貝杜 (Nicolas Bertoux) 1952 年出生於法國巴黎，職涯始於室內建築師，後轉向雕塑創作，作品廣布歐洲、臺灣的公共空間和私宅豪邸，如史特拉斯堡歐洲議會和法國朗香鎮。

54

以「石」出發，門戶上的時空行旅

藝術家薩璨如與法籍雕刻家尼古拉·貝杜（Nicolas Bertoux）旅居義大利
多年，2000 年為石碇的北郊山川創作石雕公共藝術，線條形式簡單，卻精
采凝練大理石的張力美。

撰文／蔡舒湉　圖片提供／交通部高速公路局、貝杜藝術有限公司

同為大理石雕刻家，薩璨如與尼古拉·貝杜最為珍惜自然蛻變的過程。

他們說，每塊石頭都有它的個性，藝術家要去找尋，並且在每一次實踐中挑戰新的辦法，從而斬獲新驚喜。

迴旋交會　百匯門戶意象

「我們兩個人都很喜歡石頭，雕刻是最開心的一件事，而且利用自然材料做出的作品，一定要很寶貝才行！」薩璨如與尼古拉·貝杜在義大利遠端連線，回想 21 年前為石碇創作的三組石雕作品，藝術家自己也成了時空漂鳥，雙雙見證自然與人文、時間與空間的衝突與漸變。

時值臺灣公共藝術元年，尼古拉·貝杜已為新竹創作大型地景藝術，而石碇交流道暨服務區的公共藝術案是他和薩璨如剛開始攜手共創的專案之一。他們並未提取現存於地景中的元素，而是從外部眼光思索石碇的定位。

從北宜高速公路穿過雪隧路上，可以看見許多自然生態與人文開發的衝突，反映出經濟發展與環境維護的兩難。薩璨如說：「石碇連結繁忙都會與純樸鄉鎮，本質上就是一個門戶。我們想談大自然的運行、生命的循環、人類智慧之演進，還有對旅行的觀點與祝福，這些概念都結合在一起，才會成為完美的意涵。」

石材波動　標記時空漸變

旅居義大利的他們，選擇雕鑿三組石雕來定位石碇的過渡本質。《大地脈動》位於國道 5 號石碇隧道南口綠地，六件石雕漸次地開展出明度與高度，造型似浪湧、也似層巒，在旋轉舒展間環擁出帷幕感；《時空漂鳥》棲息在石碇休息站安全島上，

水平而悠緩的形體在中央扭身繞向，既是翔翔的羽翼寄寓城鄉逍遙遊，也象徵交流道的迴旋交會，兩組作品皆使用灰白的義大利卡拉大理石。位於石碇休息站庭園的《光陰隧道》，則選用南非紅花崗石打造五座環型石雕，在反映通道本質之外，亦是孩童嬉戲的樂遊園。

三組石雕匍匐於地表之上，自然的弧度和優雅的律動感，觸發半隱半現的張力美，如同生命的交會，反映出人總在不知不覺間牽引心靈悸動。儘管作品凝聚出永恆感，團隊在創作當下卻面臨緊迫的時程挑戰，光是尋找石材就花費三個月時間。1999 年發生 921 大地震後，所有合約退回審議，建築出身的尼古拉・貝杜重新檢視結構計算、施工方法，接著在一年內陸續完成三組作品，再從義大利海運來臺灣。為求精準落實完美度，跨海團隊在工程聯絡、合約確認上都花費不少時間。

留住永恆 經營時代之美

尼古拉・貝杜說，執行公共藝術案不僅要連結當地的自然人文、藝術與工程專業人員，還要對抗諸多不可抗的天災地變，過程中需與許多人互動，而藝術品也應為人而生，連結私密的生命經驗，或連結公共議題，而不是深藏在畫廊或博物館中。埃及或希臘羅馬流傳至今偉大的石雕藝術，即證明雕刻可以是亙古流傳的地景。儘管高速公路上的公共藝術必須以安全為第一要務，無法讓駕駛者任意下車撫摸互動，依然可以透過簡單的形體變化，創造特殊的感官印象，繼而發酵情感。

人會年老色衰，在歷經風吹日晒雨淋、落葉飄落等自然衝擊，與人為的空氣汙染後，石雕也會有歲月痕跡。作品在後續保護維養上，就像沒人會把佛羅倫斯的石雕拆掉一樣，投入心力留住時代的永恆美感。薩璨如自嘲自己和夥伴都是傳統派，喜歡美、要求美，認為創作需深入與公眾對話、連結情感。「藝術家要自我要求，從內心深處挖掘出想說的故事，而不是停留在表面做不著邊際的空想。我們希望公眾可以停下來，也可以坐上去，真正地摸它、了解它。任何藝術品都需要經過時間的試煉。」

> 我們希望公眾可以停下來，也可以坐上去，真正地摸它、了解它。

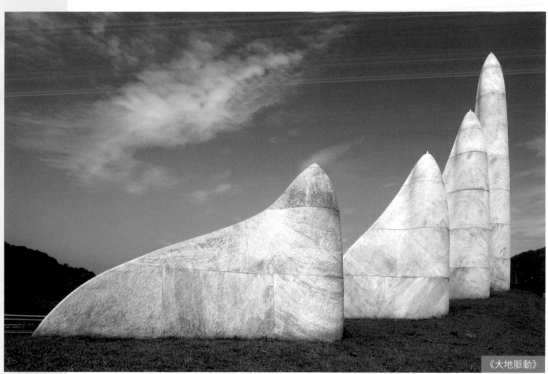
《大地脈動》

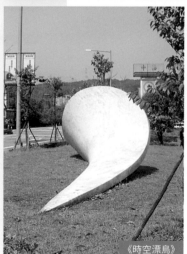
《時空漂鳥》

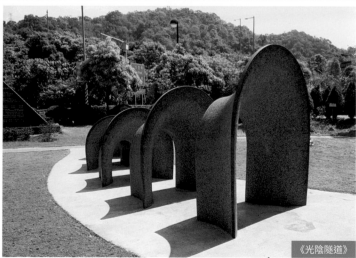
《光陰隧道》

To Depart from Stones and Travel Through Space-Time

The Italy based artist Cynthia Sah and French sculptor Nicolas Bertoux created in 2000 a public art series composed of stone sculptures installed in Shiding District of New Taipei City. Marble's dynamic beauty is exquisitely showcased by these artworks created using simple lines and forms.

Written by **Shu-Tien Tsai** Translation by **Hui-Fen Liao** Images Courtesy of **Freeway Bureau, MOTC, B & P ART CO., LTD.**

Cynthia Sah

Sah was born in Hong Kong and grew up in Taiwan. She received an MA in Art and Art Education from Columbia University. She then went to Italy to begin her creative journey in sculpture.

Nicolas Bertoux

Nicolas Bertoux began his career as an interior architect and later transitioned into sculpture. His artworks can be found in Europe and Taiwan, including the European Parliament of Strasbourg and in the Town of Ronchamp in France.

Cynthia Sah and Nicolas Bertoux are both marble sculptors who treasure the process where natural metamorphosis takes place. They think each stone is unique, and as artists, they explore and find new ways to overcome the challenges faced in each endeavor and are in turn awarded with new surprises and delights.

Revolving Rendezvous, Medley of Portal Imageries

It was a time when public art was about to take off in Taiwan. Nicolas Bertoux had already created a monumental artworks for Hsinchu, and the public art project for the Shiding Interchange & Service Area was one of the projects that he and Cynthia Sah were about to co-create.

They decided to create three stone sculptures to showcase Shiding's transitional quality. Sequence is located on the green zone at Shiding tunnel. Composed of six stone sculptures, the artwork gradually extends out to show variations of color and height. Like roaring waves and undulating mountains, the pieces turn and spread out to create curtain-like effects. Moebius rests on a divisional island in the Shiding Service Area and is a horizontal and relaxed form with a twist in the middle. It symbolizes soaring wings and also the interchange junction. Standing in the garden of the Shiding Service Area, Tunnel reflects the essence of a thoroughfare and also functions as a playground.

We want people to stop by, sit on the artworks, touch and understand them.

1. Sequence
2. Tunnel

These three sets of undulating stone sculptures show natural contours and graceful rhythmic qualities, and the subtle dynamic beauty their project seems to convey a sense of eternity.

To Grasp Eternity and Capture Beauty of the Zeitgeist

Nicolas Bertoux says the execution of public art projects needs to bring together local specialists from the areas of environment, culture, art, and engineering, and also needs to overcome unforeseeable natural disasters and changes. The artworks also need to keep the people in mind and resonate with personal experiences in life or connect with public issues. These artworks are not intended to be collected in galleries or museums. Safety is of utmost importance for public artworks installed along freeways, and although users of the road are unable to freely step out of their vehicles to touch or interact with the artworks, the artworks should, nevertheless, aim to leave unique impressions and evoke lasting emotions. Cynthia Sah adds that art needs to be able to form personal dialogues and emotional ties with people. Sah thinks that artists should search within themselves and find stories that they want to tell and not just linger on the surface and ponder on insignificant things. We want people to stop by, sit on the artworks, touch and understand them. All artworks need to go through the test of time.

胡復金 1945 年出生於中壢，就讀復興美工，美國哥倫比亞學院深造，專長是油畫、馬賽克壁畫、水彩。早年從事美工與布花設計，1984 年重拾畫筆，2018 年成立臺灣文化藝術公益協會。

胡復金

在飄動中發現美感，勤耕人文美學

在國道 3 號基隆汐止段系統交流道匝道間，胡復金運用電桿水泥柱與玻璃馬
賽克等素材創作大型公共藝術，形體以玉如意與潮水為喻，形塑連結人文的
吉祥寓意。

撰文／蔡舒湉　攝影／蘇威銘　翻譯／廖蕙芬　圖片提供／交通部高速公路局、胡復金

在回歸畫家身分前，胡復金也做過布料設計工作，他說：「布花穿在女孩子身上都是做動態呈現的，設計布花我總是晃動圖稿，檢視在動態中能否發現美感。」他不僅改變布商對設計的既定想法，也用新的方式影響公共藝術思維。

看天下　進羅浮宮修復部門

胡復金的住家兼工作室滿屋子都是畫和繪畫工具，家眷隨手指著牆上畫作，皆是從歐洲帶回收藏的古老油畫。他以「進羅浮宮修復部的亞洲第二人」作為自我介紹開場白，能赴歐洲和美國進修藝術，在當時誠非易事，也奠定他對現代藝術扎實的概念基礎。「我看了四千多張名畫的 X 光片，讓我深度認識材料運用與觀念。繪畫元素基本上相同，但發展出各種面向。從西洋現代藝術的演變足跡，可以發現都回溯至傳統技巧，主要因為人的因素而有不同的表達。」

胡復金 1977 年受聘赴印尼萬隆創建布花工廠及壁紙工廠，後來因為一場大病切除膽囊，從病床中醒來時，他自覺應該找回被稱為天才畫家的過程，藝術人生從頭再來過。「我將圓球、方形、三角錐融入生活經驗，在作品中呈現生活日常。我做過衣服的布花改變市場概念，常常覺得一個設計工作者，若不能超越商人的眼光，就會停留在工具層次，不能成為真正的設計師。」他在不惑之年拜師楊三郎，追隨國寶級畫家上山下海寫生作畫，也感染其關懷土地、推動臺灣美術運動的熱血，多元化的創作洋溢溫馨的生命力。

遇如意　在飄動中邂逅美感

胡復金認為，自己所有創作都是找尋

美感的過程。他以寫實手法描繪生機蓬勃的大地風光，「整個野外都是我的畫室」，同時也將顫動的自然脈動寫入公共藝術裡。在 921 大地震之後，他發現原先經費新臺幣 2,000 萬元的計畫案降為 1,000 萬元，自忖這個規模最適合自己發揮，於是召集團隊為沉寂的汐止臺地創作《行車動畫——如意與潮》。

作品排列疏密有致的電線桿，利用視覺錯覺呈現不同的重疊幅度；柱身包覆紅黃黑白玻璃馬賽克，善用鮮豔的原色對話藍天綠地，從形體線條塑造出層層潮汐的躍動感。

「用路人的感受是重要的，當駕駛人快速駛過高速公路，你希望讓人家在周邊場域看到什麼？公共藝術要顧及安全，也需要考慮環境，結合這塊土地。」胡復金爬梳汐止的地理背景，從基隆河漲潮提煉出水翻轉之意象，再由水墨畫勾勒的潮流簡化出符號，這個造型也像是中國古玉器「如意」，自天空鳥瞰，恰恰是一把吉祥寶器置放在大地上，既以強烈的律動性暗喻汐止的水流與車流，也用「玉如意」為高速公路送上「遇如意」的古雅祝福。

關動機 藝術工作者不為填空

要在臺地上綁支柱並不容易，完工後，《行車動畫——如意與潮》在三年的維修期內每半年清洗一次，至今屹立 20 年。胡復金說，每逢颱風、地震後，他前往勘查作品都發現狀態良好，這得歸功於當初以高標準施作。他想改變設計和藝術觀點，更希望改變作品與環境的關係，那塊土地上依舊生長著臺灣原生種。隨著都市建設日益繁榮，作品也得因應時代做變化，例如燈光配置必須注意不影響駕駛人視線或造成光害，並兼顧藝術美感。

長途駕駛過程，駕駛人難免感到無聊疲憊，胡復金認為公共藝術可以在無形中製造聯想與情緒起伏，進而改變想法，所以創作時致力於舒適感、動態感和令人愉悅振奮。他期望政府在每個單位都安排一個藝術家，在每個空間角落孕育藝術思考，同時也提醒公共藝術工作者應避免落入填空身分，創作需找到源頭動機，思索特定時空中的需要是什麼。「我不贊成天才的說法，我認為創造一個好的學習環境，加上好的指導老師是很重要的，認真用心是邁向成功的唯一途徑。」

公共藝術可以在無形中製造聯想與情緒起伏，進而改變想法。

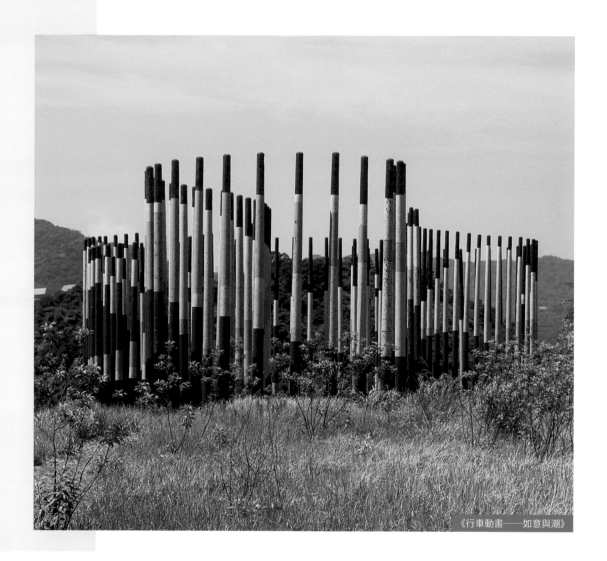

《行車動畫──如意與潮》

Encountering Beauty in Motion, Diligently Devoted to Culture and Art

At an interchange ramp on the Keelung to Xizhi section of the National Freeway No. 3 is a large-scale public artwork created by Hu-Fuchin. Composed of concrete electric poles and mosaic glass tiles, the artwork is shaped like a jade ruyi, an auspicious ceremonial scepter, and is a metaphor for the tides, with cultural and auspicious meanings evoked.

Written by **Shu-Tien Tsai** Photography by **Wel-Ming Su** Translation by **Hui-Fen Liao** Images Courtesy of **Freeway Bureau, MOTC, Hu-Fuchin**

Hu-Fuchin

Born in Chungli, Taiwan in 1945, Hu-Fuchin attended the Fu-Hsin Arts and Trade School and later studied at the Columbia University in the U.S. He specializes in oil painting, mosaic mural, and watercolor. After working in the fields of graphic design and textile design, he transitioned back to painting again in 1984. Hu founded the Taiwan Cultural and Art Charity Association in 2018.

Before he transitioned back to working as an artist, Hu-Fuchin worked as a textile designer. He would inspect his textile designs by shaking his sketches, checking to see if they would look beautiful when in motion. His approach changed the conventional ways that the textile manufacturer thought about design, and Hu also continues to use new methods to impact how public art is considered.

"The second person from Asia to work in the Louvre's conservation department" is listed on Hu-Fuchin's credentials. It was not an easy feat at that time to work in the field of art conservation in the West, and the experience has also provided him with a solid foundation on modern art.

Hu worked in the field of graphic design after he completed his military duties. In 1977, he was hired to set up a textile and wallpaper factory in Bandung, Indonesia. He later fell seriously ill and had his gallbladder surgically removed. As he was on his sickbed, he recalled how he was once referred by others as a "genius artist" and realized that he should restart his art career. In his 40s, he asked the national-treasure artist San-Lang Yang to mentor him and followed his teacher to various places to paint en plein air. Yang's love for the land also deeply impacted Hu, as well as his determination to push for the development of art in Taiwan and his richly diverse creativity and heartwarming vitality.

Encountering Auspiciousness, Encountering Beauty in Motion

Hu believes that art making is a process of finding beauty. He uses realism techniques to depict vividly energetic natural landscapes and also incorporates nature's pulsing dynamics into public art. He created Moving Painting – Ruyi and Tide after the 921 Earthquakes in Taiwan. The artwork is composed of a series of electric poles, using visual displacement to create an undulating overlapped composition. The poles are paved with glass mosaic tiles in the colors of red, yellow, black, and white, juxtaposing the vibrant colors against the blue sky and green field. The shapes and lines of the artwork form a sense of leaping dynamic that evokes overlapping tides.

The artwork is also shaped like the ancient Chinese jade scepter, ruyi. Looking down from a bird's eye view, it appears like an auspicious ceremonial scepter is placed on the land. The powerful rhythmic quality also suggests the area of Xizhi's moving waters and traffic flow. "Jade ruyi" is a homophone in Mandarin Chinese for "encountering auspiciousness", which presents well wishes in a graceful antiquated manner.

Moving Painting – Ruyi and Tide

Artists Should Find Your Motivation and Work Meaningfully

It has been 20 years since Moving Painting – Ruyi and Tide was installed, and Hu gives credit to the project's construction of high standards. His intention was to change the way design and art was perceived and to alter the relationship between art and its environment. As urban development continues to thrive, an artwork needs to be able to keep up with the times.

Public art creators should always find the motivation behind a project.

Hu believes that public art can evoke associations, spark emotions, and even change the way people think. Therefore, he strives to create art that brings a sense of ease and is dynamic and exhilarating to see. He also suggests that public art creators should always find the motivation behind a project and think about what is needed for the particular space-time. Determination and thoughtfulness will bring success.

捏塑互動關係，建築師「可以」創作公共藝術

身為建築師的陳健，從不設限自己的美學創作範圍，認為建築與公共藝術同
樣地是在塑造人與環境的互動關係，並藉由參與公共藝術，重新省思藝術與
建築的關係。

撰文／蔡舒湉　翻譯／廖蕙芬　圖片提供／交通部高速公路局、陳健

在網路上搜尋陳健，你可能很難找到這位低調建築人的創作主張，但身為臺北通勤族，你肯定對他的公共藝術印象深刻。位於捷運公館站的《偷窺》是國內少見的互動式公共藝術，三件裝置讓地面廣場的人得以窺探地下月臺的乘客，而月臺上的人亦可瞧見窺探者的面孔投影。窺人者同時也是被窺者，這種互為宰制的關係精采玩出空間的層次性，也恰好對照出網路社群虛實交錯的人際連結。如何反映、重塑人與環境的關係？陳健用建築和公共藝術嘗試辯明時代的虛幻與荒誕。

美學本事　建築師本是藝術家

「建築師是做工程的，懂什麼藝術？」身為建築師，陳健發現有無數建築人投入跨領域美學創作，然而他卻在公共藝術的道路上被質疑是否具備創作資格，於是對「藝術品」與「藝術家」的定義提出討論。他主張建築本為藝術的一環，既然受過美學訓練，並鑽研人、空間與景觀之間的關係，當然建築師有能力創作公共藝術。

對他而言，發想公共藝術能釋放長期受理性思維壓抑的影響，有機會卸下合理化設計的包袱，為自己的創作慾提供另一個出口。與此同時，他也在過程中重新體會學院教育的基本觀念，包括：人、物件、光影及速度間視覺變化的關係，以及造型和材料質感的純粹之美。

檢視公共藝術的本質，陳健認為藝術創作仰賴個人發揮想像力和哲思內涵，方向是突破窠臼、表現前瞻性。然而，公共性更關注與民眾互動、增加大眾對藝術品的認知度與接受度，倘若過度割捨藝術的純粹性與個人風格性，作品便容易流於甜俗。面對「公共」加「藝術」這種矛盾的

陳健 開設陳健建築師事務所，從事建築工程、室內設計、環境規劃、都市更新規劃、集合住宅及別墅社區規劃以及公共藝術創作。

陳健

編織—織

編織—編

概念碰撞，他透過玩味概念衝突性嘗試回應。例如位於新竹市明治書院停車場的「時間縫隙」，以層疊的金屬、玻璃板製造空隙構成虛幻的車型，藉此影射不存在的建築，表現曾有的地方記憶及功能轉換。

實驗形式 手法簡單卻深刻

建築師對於新材料的使用本不陌生，投入公共藝術創作時，陳健愈加膽大心細地雕琢概念，不僅跳脫傳統唯美的雕刻形式，更挑戰多樣化的材質及互動方式，強烈的企圖心尤其顯現在高公局的公開徵件案上。

每當往返機場，旅人們總是感到百感交集，陳健 2002 年完工的「洗塵」挑戰重現這種霧光交疊的空間體驗，和聚散離分的情感記憶。從國道 2 號往桃園國際機場的曲線路段，他在路緣兩側每隔 28 公尺傾角豎立一根 5 公尺長、直徑 20 公分的光柱，顧及結構與行車安全考量，最後定為純白光色。當車輛駛過，不同速度帶起木麻黃林景前的線條律動，掀起長達 700 公尺長的光浪影舞。

同年，作品《編織》則分割成「編」與「織」，兩件作品的基地超乎想像隔了 23 公里遙相呼應，帶出公路的連結本質。「編」設置在國道 3 號南投交流道的跨越橋，在橋體上附加一道揮毫似的優美金屬曲線，讓駕駛者快速穿過橋下時感到驚鴻一瞥；「織」位於南投交流道之匝道間，

結構以五顏六色的曲線形沖孔板葉片交織在超過 20 公尺高的柱列中，形象隨著行車視角移動展現出不同的姿態，在方向與距離變化中持續刺激觀者的想像力。

卸下包袱 進化公共藝術觀點

儘管公共藝術的競圖成本遠低於建築競圖，陳健有感建築師時常不被信任能創作出具高質感和精細度的模型，在徵選時較為吃虧。

他建議，創作者在模型製作階段就要充分表達出未來的形體，並加強溝通協調能力，在公共藝術漫長的落實過程必須面臨各種人際互動，相當考驗對創作理念的堅持與折衷修改的判斷力。此外，也要有妥善的長期維護管理計畫，畢竟對創作者而言，對於作品的保固期在心理上是沒有期限！

他難忘一位建築師的狂言：「我不容許任何公共藝術品放在我的建築物前，除非是我自己做的！」檢視高傲背後的抗拒心態，他認為自我意識強烈的建築師，往往在質感及形式中投射出鮮明的自我，擔憂任何無法主導的事物，例如風格性強烈的公共藝術將掠奪空間性格。

想突破重重關卡，除了努力提升、磨練自己的水平，陳健也建議在建築設計階段就加入公共藝術考量，能夠坦然面對並克服實際和心理的問題，建築師當然「可以」創作公共藝術。

公共藝術漫長的落實過程
必須面臨各種人際互動。

Shaping Interactive Relationships, Proving Architect's Public Art Capabilities

Architect Chien Chen never sets boundaries around his creative endeavors and believes that architecture and public art can both shape people's interactions and relationships with their surrounding environments. Through making public art, he also reflects on the connections between art and architecture.

Written by **Shu-Tien Tsai** Translation by **Hui-Fen Liao** Images Courtesy of **Freeway Bureau, MOTC, Chien Chen**

Chien Chen

Chien Chen founded his namesake architecture firm and specializes in projects involving architectural construction, interior design, environmental planning, urban regeneration planning, multifamily housing, and villas and community planning. He is also a public art artist.

Peep, located in Taipei's Gongguan MRT Station is one of the rare interactive public artworks in Taiwan. The three-piece installation allows people on the ground-level plaza to take a peep at the metro passengers on the underground platform. People on the platform can also see a projection of those peeping in. The one sneaking a look is also being watched, with the mutually dominating relationship leading to a playfully complex sense of space. The artwork also reflects on the interpersonal connections observed on social media, where virtuality and reality crisscross and overlap. The lowkey artist behind this public artwork, Chien Chen, brings together architecture and public art, with attempts made to discern the illusory and absurdity of the times.

Aesthetic Ability of an Architect Who is Also an Artist

As an architect, Chien Chen has noted that many architects are also involved in interdisciplinary creative arts; however, they are often confronted with doubts about their qualification for making public art. Chen sees architecture as a form of art, and architects are surely capable of creating public art due to their aesthetic training and expertise on the relationship between people, space and landscape.

Making art relies on an individual's imagination and philosophical disposition, as well as the abilities to be unconventional and progressive. Public art places further focus on public interaction and how to raise people's awareness and acceptance for a particular artwork. Excessive compromises on artistic pureness and personal style may lead to artworks that are cliché and kitsch. Dealing with the paradoxical impact between the notions of "public" and "art", Chen opts with using playful approach to present conceptually conflicting responses.

Weaving

Experimental Formats with Simple Yet Profound Methods

Straying from conventional aesthetic-oriented sculptural approach, Chen prefers to work with more challenging and diverse materials and interactive methods, and his strong ambition is shown on his projects submitted for the Freeway Bureau's open calls for entries. Dusting Off, completed in 2002, shows the artist's bold approach with creating a spatial experience that overlaps mists and light and conveys emotions and memories of gathering and separation. Knitting and Weaving, on the other hand, are two artworks that show distinctive features of the two textile techniques and are positioned 23 kilometers apart. The artworks echo with the freeway's intrinsic quality of connecting, and juxtaposed next to moving cars, the viewers' imagination is stimulated by the shifting directions and distances.

Architects are surely capable of creating public art.

Letting Go of Burdens with Evolving Perspective on Public Art

Although public art bidding is less costly than architecture bidding, however, Chen is often confronted with doubts about whether an architect is capable of creating models of refined and intricate qualities, which sometimes puts him in a disadvantaged position when competing in project biddings. In addition to working hard to improve himself and to refine his capabilities, he also suggests that public art should be incorporated during the architectural design phase of construction projects. By frankly facing and overcoming practical and mental obstacles, he is confident that architects are surely capable of creating public art.

賴純純　日本多摩美術大學院碩士，創作逾40年，形式風格多元，涵括新媒材繪畫、立體雕塑、空間裝置、觀念行動及公共藝術等各類創作，獲獎無數。

賴 純 純

同心連結溫度，創作從人性共鳴出發

賴純純以公共藝術建構個人與土地的生命脈絡。她說，藝術並非純粹孤立，
而是在特定的文化、時空下連結一地，並且聯想故事，而「締造情感交流」
是重要初衷。

撰文／綦舒治　攝影／張家堉　翻譯／廖惠分　圖片提供／交通部高速公路局

時常為城市創作公共藝術的賴純純，以用色繽紛與光線映射手法著稱，她也發現，縱使華人同樣崇尚喜氣洋洋的紅色調，隨著地區風俗不同，偏好的色階也會有所差異。

例如臺灣喜愛九重葛的桃紅，那是青春的躍動，也是棲居神獸的仙境色光。九重葛的特質是，雨水愈少，開出的花朵就愈鮮紅，恰如公共藝術無法封閉孤立，而是隨著時間、環境變化，孕育出獨特的文化代表性。

交錯共生　藝術不孤立

大跨度的鋼構拔地而起，在綠地藍天間繽紛交織，弧線造型如魚龍戲舞，其連結的正是華人古老傳說中的三靈獸：龍、鳳、麒麟，同時亦引人聯想高速公路交流道盤旋交會、首尾相連、魚貫而出的通道本質。

這是賴純純 2003 年國道公共藝術作品《美麗西湖》三件作品之一——「同心 Concentric」，位於苗栗縣西湖鄉國道 3 號北上停車場入口。她透露，靈獸鎮守是給地方的祝福，另一方面也是戲謔時事，用東方三大神獸號召當時的三大政黨齊心協力。「我不認為它們是具象，必須服膺於特定樣貌，而是符號性。抽象跟具象是西方美術脈絡下的分野，當代藝術有更自由的詮釋角度。」

與此同時，賴純純在國道 3 號西湖服務區還有另創兩組公共藝術，一是用壓克力玻璃和不鏽鋼製作、懸吊在南北人行跨越橋的「花果園」，人走過時可聞蟲鳴鳥叫音效；一是設置在戶外廣場、兼具戶外桌椅機能之花崗岩雕塑「森林」，兩者對比出全然不同的色澤、質感、重量感，造

型元素卻訴說一致的語言，詮釋出花卉、水果、白雲、太陽等自然意象，呼應山線的精緻農業。

賴純純說，公共藝術設置在交通樞紐、商店街或周邊綠地，與人接觸的方式都不同，創作時要考量作品與人的關係、被看見的時機與對話的情境，當然也可從地標意義思考，帶有訊息作用。

她的作品時常涉及色光的呈現，像是捷運南勢角站的《青春美樂地》，結合壓克力玻璃、霓虹燈，在驛站創造活潑的律動。又如高捷三多商圈站的《海洋之心》，自由流動的色光呼應高雄的海港與臺灣的島嶼性格，粼粼的彩光亦如繁華夜都市，時髦男女相偕逛街購物。

她觀察臺灣的特質是青春，歷經不同殖民者與世代交替，蛻變出豐富的文化風貌，並保有顫動的活力。

保存藝術 普及走向精緻化

公共藝術有其生命歷程，所處環境也會發生變化，進而影響作品的呈現。賴純純為古坑服務區創作的《蜻蜓》，呼應稻米之鄉雲林，帶出生態保育議題及農家生活記憶。

「戶外景觀雕塑的尺度很重要，要透過製作模型，讓自己更具體地思考是否掌握恰當的尺度。此外也要實際考慮到後續管理和維養。就算是不鏽鋼也需要清潔保養，臺灣有烈陽、暴雨、灰塵、地震等自然威脅，一旦運用到科技，元件汰換的速度又更快。」

然而賴純純也深諳每個人對藝術性的認知不同，認為公共藝術應從普及化走向精緻化，數量氾濫會稀釋品質，也不該只是追求視覺喜悅，而是要檢驗內涵是否禁得起時間的拋洗，公共藝術是藝術家為特定時空打造，占據一地的時間也該經過檢討把關。

引起討論 感動共通人性

為創作公共藝術，賴純純可說是跑遍全臺鄉鎮，翻閱地圖深入未知的地域。

她注重與人民交流，更透過作品協調地方意識。譬如為臺鐵長榮大學站創作的馬賽克藝術《大潭、長榮》，以大樹象徵長榮大學，以潭邊樹影代表大潭村，樹與影意象兩相對話下，表達大潭村與長榮大學共生共榮的關係。

她分享，舊金山操作公共藝術會率先貼告示、辦公聽會，讓公眾得以了解、進而參與。良善的公共機制可以引起公眾討論。「有溫度是重要的，我時常反問自己能否做一件跟地方有情感交流的作品。」

論及在地文化，賴純純主張每個地方都有其文化特質，也有人性共通的感動。「做公共藝術很辛苦，得耗費許多時間、經費與民間藝術家的能量。倘若藝術家的創作能夠提升普世認同，便是很高檔次的創作。」

有溫度是重要的，我時常反問自己，能否做一件跟地方有情感交流的作品。

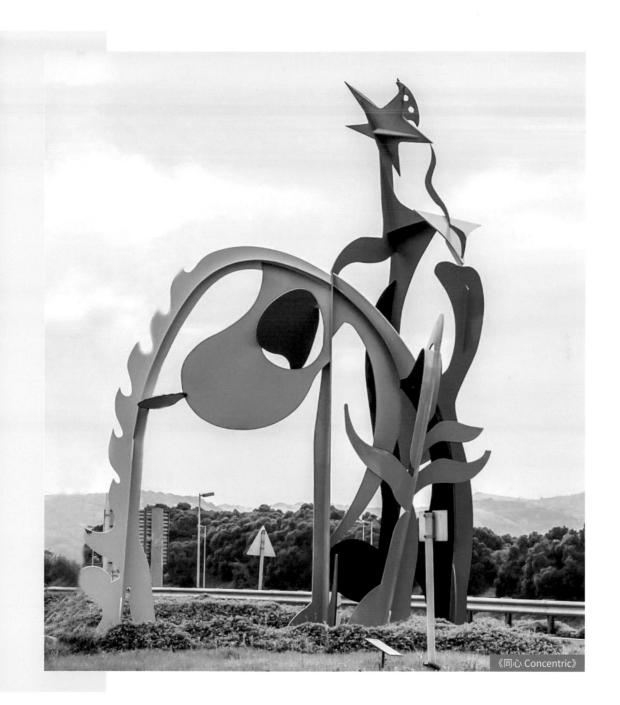

《同心 Concentric》

Concentric Connection of Warmth, Art that Resonates with Humanity

Jun T. Lai creates public art to connect individuals and the land. She thinks that art is not about exclusivity but is about stories that link with specific cultures and space-times, and to evoke emotional exchanges should be art's original and most integral objective.

Written by **Shu-Tien Tsai** Photography by **Chia-Wei Chang** Translation by **Hui-Fen Liao** Images Courtesy of **Freeway Bureau, MOTC**

Jun T. Lai

Jun T. Lai holds a master's degree from Tama Art University, Japan, and has been actively making art for over four decades. Known for her diverse creative styles, Lai is an artist who specializes in different genres, including new media painting, sculpture, spatial installation, conceptual performance, and public art. She has also been recognized with numerous awards.

Jun T. Lai has created many urban public artworks and is known for her use of vivid colors and light reflections. Lai has discovered that although most ethnic Chinese people adore the festive color of red, but different regional customs have also resulted in people's distinctive preferences for colors of different scales.

Interlacing Symbiosis, Art is Not Alone

An expansive steel structure shoots up from the ground, and vibrantly crisscrossing between the green land and the blue sky are contours and shapes that resemble dancing fish and dragon, prompting associations of the three ancient mythical beasts: the dragon, phoenix, and qilin, or Chinese unicorn. The artwork also alludes to crisscrossing highways and intersections. This artwork, Concentric, was created by Jun T. Lai in 2003.

There are also two other public artworks created by Lai for National Freeway No.3's Xihu Service Area. One is Garden / Orchard, which is composed of plexiglass and stainless steel and suspends over the pedestrian overpass that connects the south and north sides. The artwork makes insect and bird sounds when someone passes by. The other piece is Forest, which is a granite sculpture that also functions as outdoor furniture. The two artworks showcase completely

different colors, textures, and shapes but also come together to convey natural impressions of flowers, fruits, clouds, and the sun, corresponding with the nearby area's exceptional agricultural industry.

Lai is also the artist behind Dragonfly installed at the Gukeng Service Area. The artwork echoes with the county of Yunlin's moniker, "Home of Rice", and also alludes to environmental conservation issues and farm life memories.

Lai is well aware that each person sees art differently and suggests that public art should shift from being ubiquitous to a more refined direction, because excessiveness in quantity can often undermine quality. Furthermore, visual appeal should not be the sole objective, and more emphasis should be placed on whether an artwork can withstand the test of time. Public art is created specifically for a particular spatial and temporal setting, and meticulous consideration should be carried out to ensure that it is strong enough to last.

Garden / Orchard

Sparking Conversations, Moving Common Humanity

In order to create public art, Lai has traveled to various places in Taiwan, where she has ventured deep into lesser-known areas. She values interacting with people and uses art to align with local community consciousness. "It is important to project a sense of warmth. I often ask myself if the artwork I'm creating is able to connect with the local area on an emotional level."

In terms of local culture, Lai believes that each place has its own unique culture and has the power to move common humanity. "Creating public art is challenging. It demands a lot of time, money, and artistic energy. An artwork of exceptional value is one that is capable of inspiring higher universal recognition."

I often ask myself if the artwork I'm creating is able to connect with the local area on an emotional level.

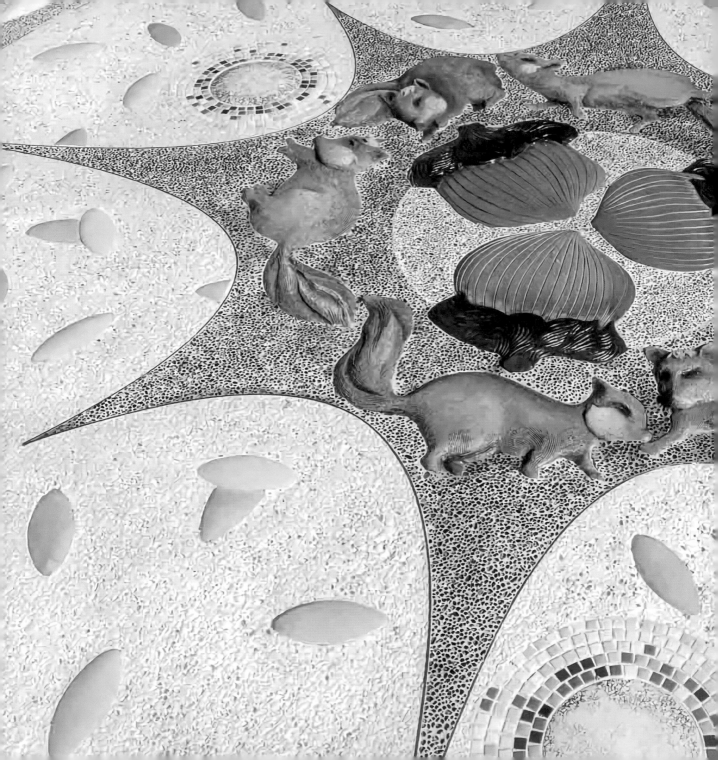

動 靜 之 間

此時的國道亮點聚焦於服務區，仁德與泰安，一南一北提
供用路人歇息與遊玩的絕佳體驗。不論是主打文學與藝術
相遇，讓休息區內藉由雕塑作品與五顏六色的繽紛配色，
呼應來往的人潮與車流，或打造孩子們的快樂天堂。藝術
不只聚焦美感，更肩負串聯人與公共性的使命。

轉動天下第一驛站，掀開音樂童話立體書

2014 年，陶亞倫為泰安服務區南站創作《幸福驛站》，包含「花園中的音樂木馬」與「餐桌下的祕密基地」兩組公共藝術，讓民眾在休憩中潛移默化經典后里印象。

撰文／蔡舒湉　攝影／蘇威銘　翻譯／廖蕙芬　圖片提供／交通部高速公路局、陶亞倫

談起為「天下第一驛站」創作公共藝術，臺灣新藝術先鋒陶亞倫用兩件作品坐鎮泰安服務區，並精采地用童話世界串聯后里地域。

烙印好客的后里印象

自從中山高速公路在 1978 年全線通車後，無論南來北往、短程長途，所有車子都會在泰安服務區停靠。2014 年陶亞倫受邀比件創作公共藝術，他挖掘后里豐富的人文地理特色，發現全世界有三分之一的薩克斯風都在臺中市后里區出品；這樂器之鄉同時也是名駒之鄉，后里馬場在日治時期是臺灣總督府產馬牧場，二戰後成立聯勤種馬牧場，現轉型為觀光休閒馬場，成為國內最完善的馬匹訓練中心。而鄰近的麗寶樂園前身則是月眉育樂世界，是臺灣第一個主題娛樂式定點度假中心；中社花市、花卉產業文化館、花田拼布公園更聯合成「臺灣後花園」，切花產量占全國 70% 之多；此外還有長達 12 公里、沿途的后豐鐵馬道，呼應腳踏車王國的美譽。

泰安服務區的改造重生肩負行銷地方人文與觀光農業的任務，陶亞倫視之為輻射文化的核心，在兩座公共藝術中兼容並蓄在地元素，並結合街道家具、遊憩設施、兒童遊具、導覽地圖等多元功能。特別是童話世界架構，在地居民與旅人一看到作品，無不興奮地衝入園區遊玩，實現「讓過客成為常客，常客成為家人」之理想。

營造巨大的驚奇與想像

公共藝術的設置地點關乎能否被充分關注。陶亞倫說，原先服務區也設有兒童遊樂設施，但因位居前段廣場，當家長進入後段休息，往往將孩子帶在身邊看顧，

陶亞倫

陶亞倫 1966年生於臺灣臺北。1993年畢業於國立臺灣師範大學美術系，1999年取得國立臺南藝術大學造形藝術碩士學位，為臺灣新藝術先鋒。

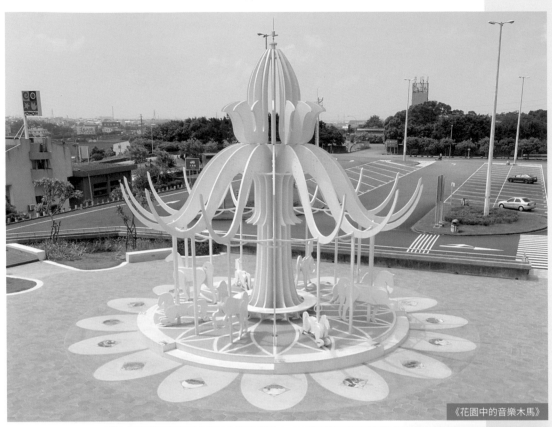
《花園中的音樂木馬》

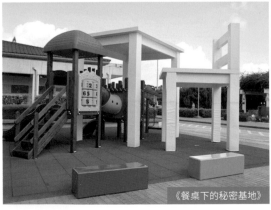
《餐桌下的秘密基地》

《餐桌下的秘密基地》

有感就會有回憶，作品如同漣漪層層擴散。

以致於遊樂區乏人問津，因此修建時便將原有的遊戲區往後移。位於北面廣場「餐桌下的祕密基地」在巨大的餐桌椅下方設置繽紛的兒童遊具，小朋友遊戲時有巨人國的大桌椅遮蔽，構成安心的親子遊憩區。「國道公共藝術大部分設置在戶外，通常是附屬於建築物。其實藝術家可以和建築師一起同步進行設計和施工作業，甚至讓建築物也成為藝術作品。」

位於南面廣場的「花園中的音樂木馬」以立體書打開的摺頁表現，純白色結構輕盈喜悅，整合薩克斯風、后里馬場、麗寶樂園、中社花海等主題元素。由薩克斯風組合成的巨大花朵，同時也是大遮陽棚。地面上有 12 個指引，掃描 QR Code 即可通往后里的 12 個景點，是有趣又實用的互動旅遊地圖。「民眾參與是軟性的行動，關乎藝術家如何將民眾創作的能量主導成具精神性的形式，讓外地人一看就能體驗在地文化。」這夢幻的遊樂園，也順理成章地成為服務區戶外展演的絕佳場地。

溝通大眾、開放藝術想像

從提案到完成製作，費時約兩年，陶亞倫認為過程中花最多時間的是審議和製作過程，「溝通協調是最重要的，如果施工步驟無法精準搭配，可能因重複施工而浪費人力與經費。」此外，公共藝術並非收歸中央統管，而是交由各機關承辦人，該員不一定熟悉藝術，若將藝術家視為一般廠商，許多細節與問題可能難以有效應變。在檢討面，儘管兩件作品耐候、好維護，但來自大停車場的遊覽車與貨運車日積月累地排放油煙，汙染物乘著風勢沾染在純白的旋轉木馬與大餐桌表面，為避免有礙觀瞻，定期清潔保養是基本功課。

陶亞倫提醒，臺灣公共藝術創作偏向協調的藝術，在溝通過程應相互尊重、找出平衡點。「純藝術是開放性的，觀眾會自己延伸想像，有感就會有回憶，作品如同漣漪層層擴散；公共藝術是面對大眾，對我來講有點像作文比賽，不能將自己的好惡放在公共場域，應以大眾觀點為主。」

他主張藝術家的任務是符合大方向與精神，並觀察出基地裡更細微的特質，在滿足業主預設想法之外，還可以超越期望，提出意料之外的想法。「我希望我的作品可以將層次拉高、拉深。」

Spinning the World's Top Post Station, Opening Up a Musical Fairytale Pop-Up Book

In 2014, Ya-Lun Tao created the project, Blissful Post Station, for the Taian Service Area's South Station, which includes the two public artworks, Secret Place Under the Dining Table and Carousel in the Garden, with the district of Houli's iconic elements incorporated in the rest stop.

Written by **Shu-Tien Tsai** Photography by **Wel-Ming Su** Translation by **Hui-Fen Liao** Images Courtesy of **Freeway Bureau, MOTC, Ya-Lun Tao**

Ya-Lun Tao

Born in 1966 in Taipei, Taiwan, Ya-Lun Tao graduated from the Department of Fine Arts of National Taiwan Normal University in 1933 and then obtained a master's degree from the Graduate Institute of Plastic Arts, Tainan National University of the Arts in 1999. He is revered as a new art vanguard in Taiwan.

Working on the public art project for the Taian Service Area, which is referred to as "The World's Top Post Station", Taiwan's new art vanguard Ya-Lun Tao decided to create two artworks and used an exciting fairytale world with local elements to connect with the area's district of Houli.

Lasting Imprints of Houli's Hospitable Impression

When the National Freeway No. 1 was completed in 1978, every single northbound or southbound vehicle traveling in Taiwan would make a pit stop at the Taian Service Area. Ya-Lun Tao was invited to participate in the bidding of the service area's public art project in 2014, which provided him with an opportunity to discover Houli District's rich and vibrant cultural and geological features. Local elements are incorporated in these two public artworks by Tao, and with diverse practical designs incorporated, including street furniture, resting facility, playground equipment, and guide map, the vision of "turning every passerby into a regular guest, and every regular guest into family" is realized.

Creating Tremendous Delightful Surprises and Imaginations

Secret Place Under the Dining Table installed on the North Plaza presents a giant

dining table with vibrant playground equipment installed underneath. Children are able to play under the shade provided by the giant table and chairs, with a safe playground area made available for families to enjoy.

Carousel in the Garden installed on the South Square appears like pages of an open pop-up book. The white structure appears light and joyful and is incorporated with unique regional elements, such as saxophones, Houli Horse Ranch, Lihpao Land Theme Park, and the flower field in Zhongshe. The artwork shows a giant flower which is composed of several saxophone patterns, and it also functions as a large sunshade. On the ground are 12 guides, which would direct the visitors to 12 scenic destinations in Houli when they scan the QR codes on them, turning the fun artwork into a practical and interactive tour map.

Public art is presented before the general public.

Communicating with the Public, Opening Up Artistic Imaginations

It took an extensive two years from project proposal to production completion. Tao asserts that the project evaluation and production were the most time consuming. "Communication is very important. If the construction steps can't be precisely aligned, it may result in repetitive work and waste of human resources and budget." During the artwork review and inspection, it was noted that although the materials used are weather-resistant and easy to maintain, in order to maintain the artworks' optimal appearance, regular cleaning and upkeep are necessary in order to remove the exhaust fumes from passing tour buses and trucks and debris that have deposited on the surfaces of the white carousel and the large dining table.

"Public art is presented before the general public, and I think it is similar to writing essays. You can't just put down all your personal preferences out in the public but should also try to see things from the perspectives of the general public." Tao believes that the mission with creating public art is to work with the particular project's overarching theme and intended ethos, and the artist should also try to carefully observe the site's distinctive features and come up with fresh ideas.

Carousel in the Garden

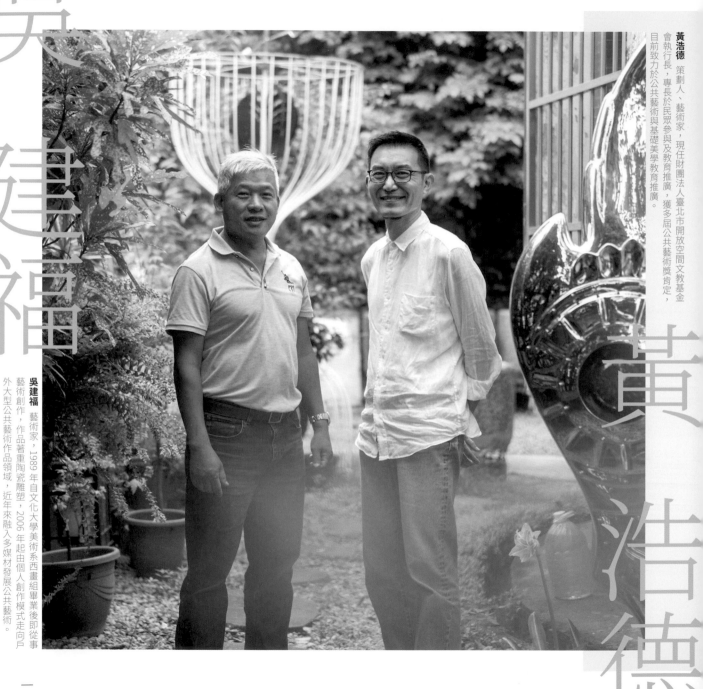

吳建福

黃浩德 策劃人、藝術家，現任財團法人臺北市開放空間文教基金會執行長，專長於民眾參與及教育推廣，獲多屆公共藝術獎肯定，目前致力於公共藝術與基礎美學教育推廣。

黃浩德

吳建福 藝術家，1989 年自文化大學美術系西畫組畢業後即從事藝術創作，作品著重陶瓷雕塑，2006 年起由個人創作模式走向戶外大型公共藝術作品領域，近年來融入多媒材發展公共藝術。

發揮童趣，打造親子用路人的小天地

馬賽克是最親切也最瑰麗的媒材，黃浩德聯手吳建福在泰安服務區打造《安安的奇幻樂園》系列作品，不僅在此戶外小型魔幻空間呈現拼貼藝術，也為孩子製造旅程期待，增加親子互動機會。

撰文／蔡舒湉　攝影／張家瑋　翻譯／廖蕙芬　圖片提供／交通部高速公路局、黃浩德、吳建福

　　為泰安服務區腦力激盪公共藝術時，眾人原先期待在前段廣場設置巨大地標象徵地域，並供民眾拍照打卡。然而這就是高速公路服務區的真諦嗎？策劃人黃浩德反覆自問：究竟何謂真正的休息？

奇幻馬賽克　為休息而戲耍

　　「很少人開車會暈車，因為駕駛是主導行動。對大人而言，停留服務區的目的也很單純，不外乎咖啡、便當、上廁所。真正痛苦的是小朋友，他處在封閉的汽車小空間中，上高速公路等同長時間被綁在椅子上，如果沒有適時紓解壓力，整趟路都會坐立難安。」不做宏偉的大地標，黃浩德選擇可停留 20 至 30 分鐘的小作品群，與吳建福攜手打造出包含《幻炫木馬》、《酷閃重機》、《蔓葉蹺蹺板》、《飄飄觔斗雲》、《電光樹精靈》、《酷樂搖搖船》、《飛天咘咘車》、《幸福轉轉輪》等八件系列作品的《安安的奇幻樂園》，不僅替小孩子與大頑童解悶，也為商家招攬熱絡的生意。

　　黃浩德在醞釀出故事雛形後，認為馬賽克鑲嵌可在戶外環境充分發揮，於是找來專攻陶瓷藝術的吳建福合作。

　　以鶯歌為基地的吳建福，推崇西班牙鬼才高第（Antoni Gaudi）和法國雕塑家妮基・桑法勒（Niki de Saint Phalle），兩人都不約而同地在開放空間展現彩色馬賽克的拼貼魔力，而臺灣也有陶瓷產業，期盼能透過藝術家的手，將此種建築材質變得更親和、具藝術性。

　　他難忘首次訪察泰安服務區時，發現後頭樹叢複雜、動線凌亂，簡直乏善可陳，在啟動連結流動性、遊具性和故事性的專案後，人人都能融入場景與不同作品產生

對應關係，隨興自適地在中程驛站收獲特殊旅行記憶。

遊具導向　不落俗的公共藝術

那麼是從藝術角度做遊具嗎？吳建福解析兩者本質不同，遊具為守護安全制訂出嚴謹的規範，如果只依循遊具規範走，無法達到藝術的各個面向，公共藝術也會難產。因此團隊在創作初期有諸多折衷調整，同時細加斟酌具象與抽象性的平衡點。例如《蔓葉蹺蹺板》最初是蠕動的毛毛蟲意象，經過不斷翻盤後，改以枝葉蔓藤的造型連結《傑克與魔豆》童話，而傳統兩端一上一下的模式，也因應家庭出遊人數改為四人座，增加全家人對話的機會；《酷樂搖搖船》以形似海蛞蝓或船的流動性線條觸發想像，並配置多達五個彈簧，期使親子同樂；《飄飄觔斗雲》的鞦韆乘坐體驗並非騰空繞彎，而是經營金箍棒與小猴子爬竿的意象，乘坐介面採用 FRP 玻璃纖維，避免不鏽鋼板吸熱發燙的問題。

黃浩德說：「吳建福過去作品有很多自由曲線和繽紛馬賽克，本身就很有想像力空間。我希望讓人一眼就能看出是他的手筆，不要失去他的個人風格。」團隊致力克服材質結構問題，在創意、美感和安全規範之間馳騁奇想。譬如地面時而鋪設橡膠地墊，時而配置沙坑。作品配置也是學問，入口處擺設較具象性的《幻炫木馬》和《酷閃重機》，愈到後面愈是天馬行空，從真實好懂的概念逐步引領遊客深入抽象魔幻。

強調互動　綿延無限的樂園

本案最細膩之處不可不提令人驚艷的繪本《安安的奇幻樂園》和系列民眾參與活動。黃浩德認為，唯有成為真正的商品，而非特定人士才可拿到的官方印刷品，才能接觸到真正的讀者，幫助家長與老師透過故事講解藝術，進而被珍惜與流傳。

他找來畫風溫暖的繪師施暖暖，文字呼應所在地后里的人文特色，串聯馬、松鼠、遊樂園、高速公路服務區、交通工具等元素說故事。「有發現沒有注音符號嗎？我向來不贊成大人把繪本丟給小朋友自行閱讀，應該是爸媽講故事給小孩聽。」

他想實踐的不只是老少咸宜的公共藝術，更包括互動與陪伴，於是選出鄰近泰安服務區的四座學府——后里國小、后里國中、泰安國小和豐陽國中，並一一到訪。在帶領民眾參與過程中，黃浩德也驚訝地發現當地人鮮少到訪泰安服務區。

透過舉辦「我的私房樂園」圖文比賽和奇幻攝影比賽，他釋放各種可能性，強調凡是能創造美好回憶者，都能喚作樂園，也期許大眾打開眼界，用更寬廣的包容性看待百花齊放的藝術。吳建福亦自勵除了擁有繽紛的藝術生命，也能肩起社會責任，「作品一旦能被社會討論，與大眾融合、玩樂，意義將大為不同。」

> 作品一旦能被社會討論，與大眾融合、玩樂，意義將大為不同。

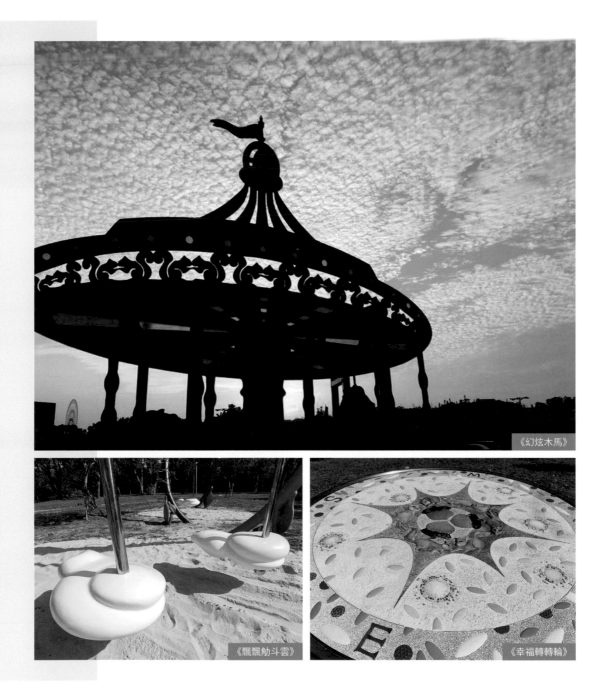

《幻炫木馬》

《飄飄觔斗雲》

《幸福轉轉輪》

Family-friendly Space Playfully Created for Road Users

Mosaic tiles are a medium that's approachable and vibrantly beautiful. Howard Huang and Chien-Fu Wu have co-created the art series, An-an's Journey in the Wonderland, at the Taian Service Area, a roadside rest stop. Presenting a small but magical space created with mosaic art, the artworks also make the children feel more eager about the journeys that they are on and create more opportunities for family interaction.

Written by **Shu-Tien Tsai** Photography by **Chia-Wei Chang** Translation by **Hui-Fen Liao** Images Courtesy of **Freeway Bureau, MOTC, Howard Huang, Chien-Fu Wu**

Howard Huang

Howard Huang is a curator, artist, and also the current director of the Foundation for Research on Open Space, Taipei. He specializes in public participation and educational promotion.

Chien-Fu Wu

Artist Wu Chien-Fu has since been dedicated in a career of art-making, specializing in ceramic sculptures. In 2006, he transitioned from personal art endeavors into the field of large-scale public art.

While brainstorming on the public art for the Taian Service Area, curator Howard Huang had thought about this extensively and asked himself the question, "What does taking a rest really mean?"

Play to Rest with Magical Mosaics

"For most adults, the reasons to stop at a freeway service area are quite simple, most likely they were there to get coffee, food, or use the restroom. However, being strapped down on a long car ride down a freeway is often quite excruciating for children." In order to offer a fun experience for both kids and grown-ups, Howard Huang and Chien-Fu Wu jointly created the series An-an's Journey in the Wonderland, which is composed of the following eight artworks: Imaginative Carousel, Sparkling Heavy Motorbike, Leaf-Shaped Seesaw, Cloud Swing, Tree Fairy, Shaky Boat, Flying Chariot, and Magic Wheel. With the launch of this project, which incorporates playground equipment designs with storytelling, everyone is invited to interact with the various artworks and create unique travel memories.

Unconventional Public Art with Playground Equipment Designs

When considering how to achieve a balance between playground equipment

and public art, the team had to make many compromises during the initial conception stage, in order to achieve a figurative and abstract balance. For example, the sprawling leaf-shaped design of Leaf-Shaped Seesaw echoes the fairytale, Jack and the Beanstalk, and it's designed to accommodate four people so more family members on an outing can join in on the fun. Shaky Boat is created with five springs, so it can be enjoyed by both children and adults, and the swing designed for Cloud Swing is made with fiber-reinforced plastic to prevent heat from being absorbed.

The team was dedicated in overcoming material and structural issues, to allow imaginative expressions to be freely displayed and for creativity, aesthetics, and safety measures to all be carefully considered. How the artworks are arranged also demanded meticulous expertise. Artworks that are more figurative are installed near the entrance, and the arrangement then grows more imaginative and gradually guides the visitors to immerse in an abstract and magical world.

An artwork can take on greatly different significance if it can prompt discussions in society and become a part of the general public's lives and be playfully enjoyed.

A Boundless Paradise with Interaction Highlighted

The incredible illustrated book, An-an's Journey in the Wonderland, is another amazing part of this project, along with the series of public participatory events organized. Howard Huang invited illustrator Noir-Noir Shih to work on the book, which uses writings and images to connect with the unique culture found in the local area, Houli District.

Also through organizing writing, drawing and photography competitions, the events emphasized that anyone who can generate wonderful memories are capable of forming a paradise, and wide and all-embracing viewpoints should be used to see different kinds of art. Chien-Fu Wu also hopes to continue to carry on with such endeavor and says, "An artwork can take on greatly different significance if it can prompt discussions in society and become a part of the general public's lives and be playfully enjoyed."

1. Leaf-Shaped Seesaw
2. Sparkling Heavy Motorbike

落實美學，公共藝術是打群體戰

陳麗杏的《清逸蓮香》以流動線條形塑桃園的蓮與鵝，姜憲明跳脫名物思維，
用甜甜圈在《甜蜜滋味》對比豐富概念，於中壢服務區玩味多元文化風情，
亦剖析出公共藝術之於環境的真諦。

撰文／蔡舒湉　攝影／張家瑋　翻譯／廖蕙芬　圖片提供／交通部高速公路局

弧線是最綺麗的線條，那是魚戲蓮葉的陣陣漣漪，也是白鵝覓食的悠哉擺翅。姜憲明與陳麗杏用蓮葉、鵝群聚焦桃園的產業，並添加新題材甜甜圈帶出繽紛童趣。他們說：「在公共藝術裡，外在形式比美學論述更重要，大眾先看外在再看內涵，造型先取是受歡迎的簡單方法。」

造型先取 營造換場驚喜

中壢服務區門口立了三朵巨大的蓮葉雕塑，三朵嫩綠彷彿三位綠仙子翩然起舞，吸引人親近駐足歇息，而一旁還有肥美可愛的母鵝帶小鵝，家禽姿態各異，為荷塘場景增添不少戲劇張力。陳麗杏用觀音、新屋區的蓮花以及新屋鵝，在《清逸蓮香》聚焦桃園兩大特色產業。為什麼捨棄爭妍鬥豔的花朵，僅用莖葉作為象徵呢？她說，花卉意象常見於藝術季與建築景觀，也較

直接外放，期望以較清新方式表現。至於結合蓮葉與涼亭概念，乃著眼於附近是客運轉運站，希望供等車的旅人遮雨庇蔭。

她提出三項公共藝術創作理念：對應周圍環境，作品需充分融入地方，延伸出整體感，並反映出時代精神與歷史意義；對於民眾，應引發參與公共藝術的興趣，自然而然地體會創作者心思；而對創作者而言，作品也能隨著時間及空間環境的不同，與創作本質發生進階式的改變。

2017 年，姜憲明、陳麗杏與鄧惠芬共同為中壢服務區創作三組公共藝術，解讀在地的眼光各自不同。姜憲明表示，先建立核心主軸再各自詮釋主題，作品樣貌可能會較相似，缺乏換場感；反之，若先放手各自發揮，後續再思考主題銜接，也不失為一種創意發揮。例如《甜蜜滋味》以甜甜圈為意象，這道席捲國際的甜食雖非

陳麗杏

姜憲明　國立臺南藝術大學（MFA）造形藝術研究所藝術創作碩士，多次獲得國內重要雕塑獎項，2001年獲花蓮國際石雕藝術季戶外創作常雕塑家。

陳麗杏　國立臺南藝術大學（MFA）造形藝術研究所藝術創作碩士，曾經獲選行政院觀光局藝術外交大使，公共藝術作品發表在國內外各地。

姜憲明

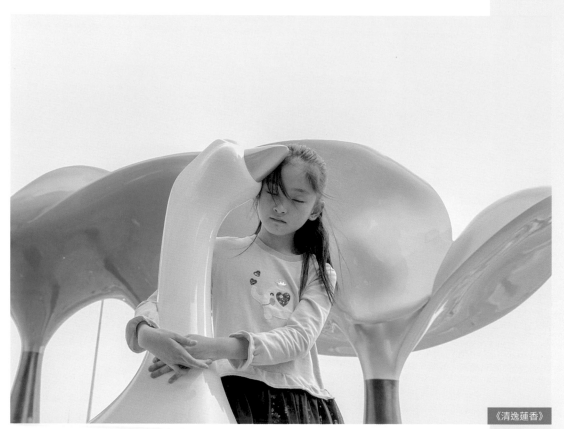
《清逸蓮香》

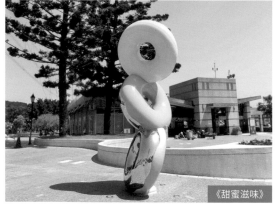
《甜蜜滋味》

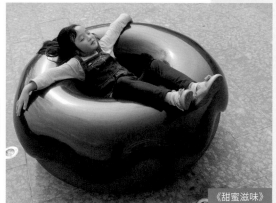
《甜蜜滋味》

一
己
之
力
無
法
做
公
共
藝
術
，

過
程
中
需
要
多
人
的
協
助
與
琢
磨
。

桃園特產，但因人見人愛，所以能賦予旅途中的幸福感。

遊戲工法 編織藝術願景

在具象與抽象之間，藝術家夫妻檔也在材質、細節與方向性中鑲嵌願景，主張設計公共藝術要考慮造型美學、可親近性與功能性。例如蓮葉下行走的鵝，尺寸恰好可供孩子攀爬，鵝群配置指引出廁所方向，爸媽如廁時，小朋友看到遊具式公共藝術，會更有耐心地在此停留嬉戲。《甜蜜滋味》分別利用立面堆疊的不鏽鋼鍛造烤漆，與地面的花崗岩石雕兩種藝術形式詮釋甜甜圈，圓弧可供民眾乘坐、攀爬，同時也透過材質與顏色對比引人聯想甜甜圈的滋味口感。

姜憲明說，雕刻是減法，去掉多餘，留下所需的結構；鍛造是加法，藉由敲打組合成型。在藝術品的設置上，立面適合拍照，有利拍多人合影、環境景觀。為避免反光影響行車視線，不鏽鋼面往內側設計。而錯落地面的甜甜圈或完整半躺、或半弧狀散置，工法上經打鑿研磨，分別呈現粗細軟硬不同感受，對應大自然中的石

頭，在經過風蝕、沖刷後，面貌也各異其趣。值得一提的是，石雕雖耐刮、好清洗，為避免積塵蓄水，鑿面採黑色，光面採白色，在創作當下就為未來的維護保養著想。

建構產業 打藝術群體戰

中壢服務區的公共藝術建置案，時間比高速公路其他地段更後期。姜憲明認為創作的確會隨時間進化手法，材料也會隨之升級，然而公共藝術打的是群體戰，作品深化出雋永本質是其一，從產業體質觀之，能無縫接軌地轉換概念、建造出精緻的實體，更是一種難能可貴的專業。「單靠一己之力無法做公共藝術，過程中需要很多人的協助與琢磨。」倘若直接交給工廠執行，藝術家的原意可能在製作過程逐漸被曲解而失真。他認為，要做出原汁原味，比較保險的作法是培養自己的工班。

美學教育是公共藝術的重要任務，因而說明牌顯得不可或缺。他們呼籲藝術家肩起社會責任，當藝術品走下美術館的臺座，在公共環境中要具備能量襯托人民與環境的價值，也唯有透過耳濡目染，方能提升國民的文化美學。

Public Art is a Group Effort
that Can Lead to Improved Appreciation for Art

Delicate Lotus Fragrance by Li-Sin Chen uses fluid lines to depict the city of Taoyuan's iconic lotus blossoms and geese. Opting to leap away from the area's popular motifs, Hsien-Ming Chiang created Taste of Sweet Donuts, using the sweet treat to convey a sense of prosperity. Together, the artworks come to project an interesting cultural appeal at the Zhongli Service Area.

Written by **Shu-Tien Tsai** Photography by **Chia-Wei Chang** Translation by **Hui-Fen Liao** Images Courtesy of **Freeway Bureau, MOTC**

Hsien-Ming Chiang

Hsien-Ming Chiang holds a master's degree from the Graduate Institute of Plastic Arts, Tainan National University of the Arts and is a winner of several major sculpture awards in Taiwan.

Li-Sin Chen

Li-Sin Chen holds a master's degree from the Graduate Institute of Plastic Arts, Tainan National University of the Arts and her public artworks are featured in both Taiwan and overseas.

Curved lines are used to create splendid contours that show ripples extending out from lotus leaves with fish frolicking underneath and also the fluttering wings of white geese scavenging for food. Hsien-Ming Chiang and Li-Sin Chen use lotus leaves and geese to highlight the local industries of Taoyuan, with donuts incorporated as a refreshing motif to create a vivid playfulness.

Delightful Experiences with Meticulously Considered Shapes and Forms

Inspired by the lotus blossoms and geese found in Guanyin and Xinwu Districts of Taoyuan, Li-Sin Chen created Delicate Lotus Fragrance to highlight these two unique industries in the area. She explains that floral imageries are often found in art festivals and architectural landscaping and are often shown in very direct and obvious ways. Her intention is to opt for a more refreshing approach. The gazebo with lotus leaf elements created by her provides a shaded area for those waiting for the bus at the nearby transfer station.

Working with both figurative and abstract elements, this husband-and-wife artist duo's vision is observed from the artworks' applied materials, details, and the intended purposes. For example, the geese underneath the lotus leaves are

designed in specific sizes to make them appropriate for children to climb on. The layout of the geese also points to the direct of a public restroom, and while the children are drawn to play with the playground-style public artwork, their parents can take turn to use the restroom.

Taste of Sweet Donuts, on the other hand, uses coated stainless steel juxtaposed with granite stone carving on the ground to create this artwork in the shape of stacked donuts. The circular shape offers a place for people to sit and climb on, and the materials and colors used also evoke the taste of sweet donuts.

> **It is impossible to make public art alone. It is a process that requires the help and dedication of many.**

Hsien-Ming Chiang explains that to avoid the reflection from the artwork from disturbing the drivers, the stainless steel side is designed to face inwards. Also, although the stone carving is scratch-resistant and easy to clean, in order to avoid debris and water from accumulating, the carved side is presented in black, while the polished side is in white, with future maintenance taken into considering during the creative process.

Building the Industry with Art Created Through Group Effort

The public artwork installation project for the Zhongli Service Area was completed later than other sections of the freeway. Hsien-Ming Chiang understands that techniques and materials used for art will always evolve but public art is a group effort, and it is essential to create something that will be timeless. To look at the local area and to seamlessly connect, inspire new ideas, and then create a sophisticated artwork, it is a process that requires admirable professionalism. "It is impossible to make public art alone. It is a process that requires the help and dedication of many."

The duo call out to other fellow artists to take on social responsibilities, and when art is taken out of art museums, it should be able to project energy in the public setting and to highlight the values of the area's people and environment. Only through constant exposure can people's ability to appreciate art and culture be elevated.

Taste of Sweet Donuts

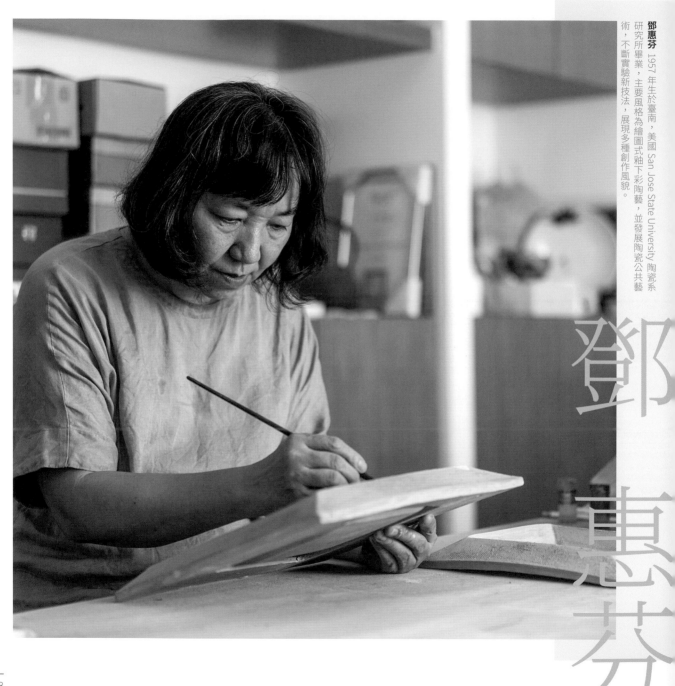

鄧惠芬 1957 年生於臺南，美國 San Jose State University 陶瓷系研究所畢業，主要風格為繪圖式釉下彩陶藝，並發展陶瓷公共藝術，不斷實驗新技法，展現多種創作風貌。

鄧惠芬

以陶訴說五月雪，款待旅客清雅小歇

陶瓷藝術家鄧惠芬的招牌是以繪圖式釉下彩拼貼出「陶藝故事繪本」，她亦
跨足公共藝術嘗試立體陶瓷，如《桐雪客居》藝術座椅，充分彰顯中壢服務
區的人文與自然。

撰文／蔡舒湉　攝影／張家瑋　翻譯／廖惠分

雙手長期捏陶，作品在水火裡來去，鄧惠芬的創作意志也和陶瓷特性一樣，注重心手相連。她說：「我對公共藝術最早的想像大多是在歐洲看到的人物雕像，大家看到就想牽起它的手，或模仿它擺姿勢。公共藝術自然而然融入環境跟社會，與人產生互動。」她為中壢服務區創作的系列陶瓷椅亦如是，《桐雪客居》安靜地佇立於大樹與草地之間，等待旅人歇腳傾心。

客居中壢 細描桐雪

生於臺南，20 歲北上就讀實踐家專美術工藝科主修空間設計，之後隨夫婿赴美國。她修陶、學平面設計，返臺後常住中壢，投入陶藝創作不輟，並指導中央大學的陶藝社。鄧惠芬笑著說，中壢可說是她住最久的城市了，她觀察中壢以客家族群為大宗，最重要的特質是客家精神，而名字也有驛站意味，為南來北往的休憩中繼點。只是每次走國道 1 號，她鮮少在中壢服務區停留，也好奇有多少旅客會走到服務區後半部遇見她的作品呢？

2017 年作品《桐雪客居》一共是六座藝術座椅，策展人陳惠婷先是設計出六張椅子，鄧惠芬再於既有的ㄇ字形長凳上利用彩色瓷版、抿石子創作，意象結合桃園古老的街屋建築及清麗的桐花，色彩則依循紅磚的棗紅帶出客家印象。為了使圖案能依椅面線條延伸，鄧惠芬將陶瓷燒成有彎角的 L 型，製作技法較為費工。本系列約花費四個月完成，彩繪能力亦受評審委員認可。「當初我想用靜態的形式讓椅子與人接觸，旅客坐在上面，能感受到創作者想傳達的概念與用心。圖騰上不見得都要中規中矩，我搭配抽象幾何圖形詮釋街屋，在加入客家元素外顯露個人特色。」

理想中的公共藝術城市是——
轉個街角就能邂逅新奇。

悄悄邂逅 深深體會

作陶逾 30 年，鄧惠芬的陶藝如同以釉彩表現的立體繪本，方圓是主要造型，同時搭載溫暖繪彩，她用純手工打造一座座童話王國，逐一造出房屋、帆船、氣球與各色小人物，而觀眾亦常常情不自禁地用手觸摸作品。對她來說，這種潛意識的呼喚是藝術最奇妙的魔法，譬如街頭一張椅子，上面結合人與狗的雕像，人們自然想並肩齊坐，並聯想出陪伴、忠誠等意涵。

然而，具象與抽象表現沒有絕對好壞。她說，普羅大眾比較能接受具象的淺顯易懂，例如霍夫曼的黃色小鴨，鮮豔可愛，尺度龐大具震撼力，人人爭相前往拍照打卡。「大家都看得懂的語言總是會被看到，但是否能撼動心房，具備永恆性與影響力，讓文化往內生根呢？」

《桐雪客居》曾因周圍施工，工人誤將水桶放置在椅子上，讓鄧惠芬不免心疼。她認為藝術察覺力光靠個人從小薰陶是不夠的，公共藝術要能連結在地性，濃縮更深層的象徵意義，創造話題外，更要與環境交互作用。無論設置在建築外牆或是地面，它能潛移默化空間氛圍、創造想像。

她看重作品與人的長遠互動，《桐雪客居》曾舉辦一次彩繪陶瓷盤工作坊，但她認為這樣的「民眾參與」固然為評比的必要，卻不是絕對重要，期待接觸到更多元的族群，讓藝術對話持續綿延。

弱勢材質 堅強轉化

中壢由於工廠林立，酸雨平均 pH 值蟬聯全臺最酸區域。陶藝家呼籲任何材質的公共藝術都該定期清洗保養，同時也感嘆陶瓷是較弱勢的媒材。「陶瓷的特色是可以上釉，在釉上彩繪。比較辛苦的是燒製的過程，種種變化如變色、縮小，或裂開。一般陶瓷藝術採平面拼貼，如果是立體造型，要先用鋼筋混凝土做成結構，還要燒製、開模、拼貼磁磚馬賽克。」

由於陶的特性較難實踐巨大尺度或有機、圓潤的造型，鄧惠芬期待陶藝創作能在工整之外，擴展出更豐富的面貌。而公共藝術在強調連結地方的基礎上，也得開放更多機會給異地的藝術家，並且協調基地周遭的藝術與地物關係。

她理想中的公共藝術城市是——轉個街角就能邂逅新奇。

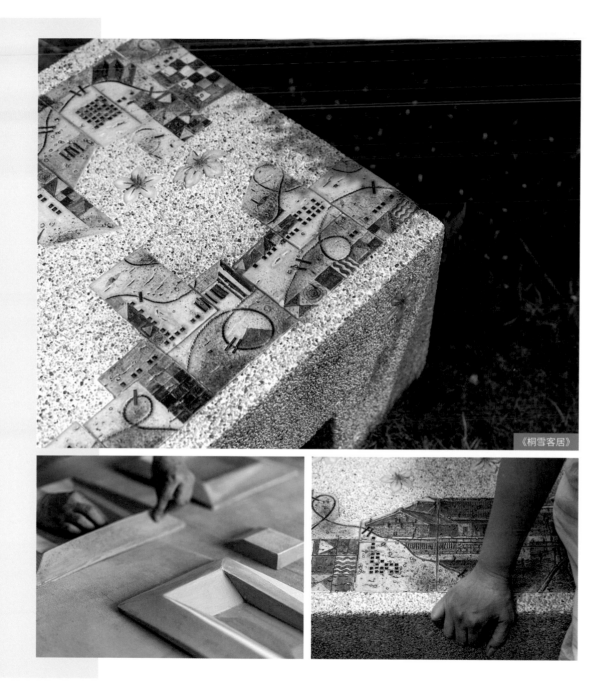

《桐雪客居》

Using Ceramic to Illustrate the May Floral Snow, Offering Graceful a Rest Stop for Travelers

Ceramic artist Hui-Fen Deng is known for ceramic art illustrated storybooks created with painterly underglaze collages. She also creates public art using ceramic in a three-dimensional manner, which is seen in her street furniture work, Hakka Homes Bedecked in Tong Flowers, a project that showcases the cultural and natural elements found in the region of the Zhongli Service Area.

Written by **Shu-Tien Tsai** Photography by **Chia-Wei Chang** Translation by **Hui-Fen Liao**

Hui-Fen Deng

Hui-Fen Deng was born in 1957 in Tainan, Taiwan. She holds a master's degree in ceramic art from San Jose State University and works primarily with painterly underglaze ceramic art and also uses ceramic to create public art. She continues to experiment with new techniques and has developed various creative styles.

Hui-Fen Deng has worked with clay for a long time, using her hands to shape her artworks which are then put through extreme heat. Deng's creative will is similar to ceramics, which places emphasis on alignment between the hands and the heart. The series of ceramic benches she has for the Zhongli Service Area is an example of her art approach. The pieces in Hakka Homes Bedecked in Tong Flowers wait quietly for travelers to stop by and take a rest.

A Resident of Zhongli Who Intricately Depicts the Iconic Tong Flowers

Deng says with a smile that Zhongli is the city where she has resided in the longest. She pays close attention to the area's large Hakka community and has noted their important Hakka spirit. The name of this artwork poetically alludes to a post station, and the artwork serves as a rest stop for travelers moving north and southbound.

Created in 2017, Hakka Homes Bedecked in Tong Flowers consists of 6 art benches. Deng used colored ceramic plates and pebbles on rectangular long benches to create images that incorporate ancient architecture from Taoyuan and the area's graceful tong flowers. The colors applied include the iconic Hakka

brick red. In order for the images created to extend out on the surfaces of the benches, Deng created L-shaped ceramic plates, which is a technique that is time consuming and meticulous.

Hakka Homes Bedecked in Tong Flowers

Quiet Encounter, Profound Realization

Workers that were doing construction work near Hakka Homes Bedecked in Tong Flowers once mistakenly placed a bucket on one of the benches. Deng couldn't help but to feel bad for the artwork. She believes that the ability to appreciate art is something that needs to reach beyond education and exposure at a young age, and public art needs to incorporate local features and bring together profound symbolic meaning. It should be able to evoke conversations and interact with its surrounding environment. An artwork, regardless being on a building façade or on the ground, it should seek to subtly influence the ambiance of the space and spark imagination.

Deng values how her art can interact with people in the long run. A ceramic plate coloring workshop was once held for Hakka Homes Bedecked in Tong Flowers, and although she thinks that such public participatory event is necessary for the evaluation and promotion of the project, but it is not absolutely crucial. She hopes to be able to interact with different groups of people and to have lasting conversations on art with them.

Public art is where people can turn around at a corner and unexpectedly encounter something new and delightful.

Diversity in Art, Powerful Transformation

It is quite challenging to use the medium of ceramic to create large-scale or rounded shapes; however, Deng looks forward to creating ceramic art that showcases diverse features. With public art, she focuses on forming connection with the local region and thinks that more opportunities should be provided to artists coming from various places, with harmony formed between the art and the regional features found around the installation site. The ideal vision she has for a city with public art is where people can turn around at a corner and unexpectedly encounter something new and delightful.

文 化 連 結

縮短藝術與人的距離，落地生根，是眼下公共藝術之所向。
當藝術家保留了雪隧導坑的 TBM，將其化作藝術品、並透
過活動規劃連結在地特性，便重新活化了藝術的定義；同
樣將 TBM 視為重要意象，以圓環造型及燈光寄寓道路與心
靈上溫柔導引，抒發出歸鄉心境，亦讓公共藝術擁有截然
不同的思考方向。

點亮雪隧返鄉情，藝術的優雅導引

「國道 5 號宜蘭段公共藝術計畫」以最具指標性的「雪山隧道」，與貫通雪隧的全斷面鑽掘機（Tunnel Boring Machine，簡稱 TBM）作為主意象，其中一件由楊尊智經公開徵選獲得設置權。

撰文／蔡舒湉　攝影／張家瑋　翻譯／廖蕙芬　圖片提供／交通部高速公路局

公共藝術的擺放位置有時也是權力的象徵，譬如高速公路服務區最重要的功能區——廁所，你會選擇將作品設在男廁、女廁，還是性別平等廁所呢？長年耕耘公共藝術的楊尊智肯定領域人士開始討論這些話題，2020 年他為蘇澳服務區創作《流動的光河》，於草坪上佇立偌大的鋼鐵光圈，以優雅的姿態述說時代巨輪無限進化。

一比一穿越雪隧 燈光導引夜歸人

作為蘇澳服務區重要的入口意象，楊尊智為《流動的光河》採取雪隧空間的真實比例，組合七個圓環構成立體圓圈環繞造型。製作過程先由擅長 3D 繪圖的林育正繪製精細的施工圖，最後耗時八個月完工。遊客可走入作品感受隧道的實際尺度，裡外部皆設置說明牌。此外還設計全彩環繞（TBM 鑽掘）、轉速意象（啟程）、歸

鄉旅程（車頭燈、車尾燈）共 15 分鐘的三段燈光展演。既表現出空間張力，也實現純粹的視覺舒適感。

楊尊智說：「乘客一下遊覽車就能看見作品，因此不只是物件造型，作品擺設的最佳打卡拍攝角度也要細心考量。」他最心儀從圓圈裡透出的日出日落，各角度都可以是端景，營造出絕佳的震撼感與美感。「公共藝術除了是有地方關懷的創作，藝術家還得掌握許多細節，推動創造基因的突變，否則會流於一種不健康的模式。」

穿梭城鄉 親民地詮釋環境

楊尊智就讀國立藝術學院（臺北藝術大學前身）美術系期間，原是鑽研抽象畫，後來因協助北藝大老師製作公共藝術模型，漸漸深入門道，自從 2003 年開始做公共藝術後，長年耕耘公共藝術圈。他對場

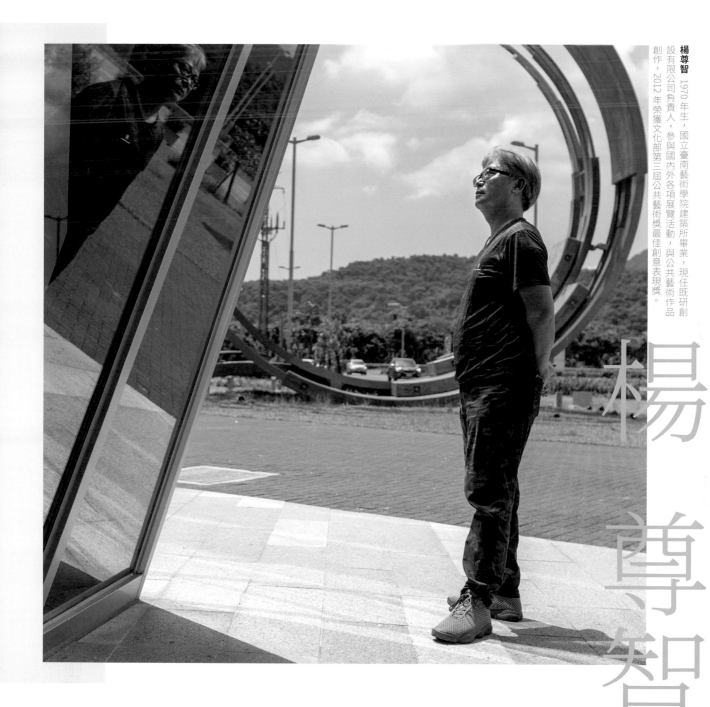

楊尊智 1970 年生，國立臺南藝術學院建築所畢業，現任既創設有限公司負責人，參與國內外各項展覽活動，與公共藝術作品創作，2012 年榮獲文化部第三屆公共藝術獎最佳創意表現獎。

楊 尊 智

《流動的光河》

域的尺度與規模感，也與攻讀國立臺南藝術學院建築所（臺南藝術大學前身）有關。「我在外島馬祖西莒服役，時常貼近泥土，燃起對空間經驗的興趣。」因為擁有美術與建築背景，楊尊智擅長融合純藝術與生活化的設計語言，時常創作出與環境相關、公眾容易詮釋美感及意會樂趣的作品。

設置於清華大學大草原區的《對奕‧對藝》雕塑，材質選用花崗石材地坪及不鏽鋼烤漆，造型以圍棋的黑白子為單元，將棋盤上的平面攻防轉為立體的垂直扭轉，其姿態也激發出棋士對弈的緊繃張力。位於國立公共資訊圖書館的《讀樂‧無限‧大未來》，則從「閱讀無限」概念出發，運用不鏽鋼、大理石形塑持續流動的無限符號「∞」，同時結合休憩座椅功能，觀眾可自各視角親近體驗。楊尊智擅長輕巧轉化主題意象，並以俐落線條造型深入人心，因此能在公共藝術界占據一席之地。

大眾觀點 勤墾公共藝術圈

他關注公眾的回饋，時而查看蘇澳服務區的打卡點，觀察體驗者如何評斷《流動的光河》，其中最令楊尊智感共鳴的形容是——可以穿越時空的時光機。「我最早的公共藝術是 2003 年設置在宜蘭的作品，那時雪隧尚未通車，創作期間每天早出晚歸，常常天還沒亮就出門工作，一路上對黑暗中的發光的車頭燈、車尾燈畫面感受良深。」而雪隧漫長的 12.9 公里路程，也是藝術家沉澱心境、檢討作品的好時機，於是他在《流動的光河》以弧形圓圈結構連結圓形的車燈，寄寓道路上與心靈上的導引，溫柔而隱晦地抒發歸鄉心情。

不只是公共藝術創作者，楊尊智也擔任公共藝術的評選委員。他觀察許多公共藝術專案之所以令藝術家望而生畏，乃是因為流程太過繁複，此外，工程在公共藝術占很大的比例，必須協調利潤分配與創作發揮。「藝術家是否願意付出，決定案子的成敗。會有『民眾參與』評比項目，用意是強調藝術家不能自言自語，而是要用作品和行動與每個人對話。」他自言會走這條路是因為曾經獲得相關獎項，並且可以在一般創作者所沒有的舞臺施展手腳，充分獲得成就感。未來他會持續耕耘，也期待未來社會各界對於公共藝術會有更多不同的思考。

Using Art To Gracefully Light Up the Hsuehshan Tunnel Homebound Journey

"The National Freeway No. 5 Yilan Section Public Art Project" highlights the iconic Hsuehshan Tunnel and the "tunnel boring machine" (TBM) used to excavate the tunnel, which led to the births of two artworks, and one of them is Moving Light by Tsun-Chih Yang, which was selected through an open call for entries.

Written by **Shu-Tien Tsai** Photography by **Chia-Wei Chang** Translation by **Hui-Fen Liao** Images Courtesy of **Freeway Bureau, MOTC**

Tsun-Chih Yang

Tsun-Chih Yang holds a master's degree in architecture from the Tainan National College of the Arts. He actively participates in local and international exhibitions and creates public artworks. In 2012, he was presented by the Ministry of Culture with the 3th Public Arts Awards' Best Creativity Award.

Tsun-Chih Yang, an artist with many years of public art experience, created Moving Light for the Suao Service Area in 2020. Presenting a mammoth circular structure installed on a grassy lawn, time's infinite progression is expressed with the graceful artwork.

Lighting Up the Nighttime Homebound Path, Using a 1:1 Ratio to Travel Through Hsuehshan Tunnel

As an important monument located by the entrance of the Suao Service Area, Moving Light created by Yang references the actual spatial ratio of the Hsuehshan Tunnel, with seven rings used to create a twirling circular shape. The production process began with meticulous construction drawings created by 3D computer graphics specialist, Yu-Cheng Lin. The ensuing construction then took eight months to complete. Furthermore, three lighting displays showing impressions of circulation in full color (TBM drilling), rotational speed (embarking on the journey), and homebound (headlights and taillights) are designed, with a spatially dynamic and visually pleasant experience showcased with the 30-minute presentation.

Tsun-Chih Yang studied art in college, and although abstract painting was his initial focus, he later transitioned to public art after he started making models

> The success of a project is dictated by the artist's level of dedication.

for public artworks for his teachers. He started to make public art in 2003 and remains an active figure in the public art community. Yang also has a master's degree in architecture, which is why he is exceptionally perceptive towards the sense of scale and scope of any given space. Because of his background in art and architecture, Yang specializes in combining elements of fine art and everyday lifestyle design and creates artworks that are connected to the environment and relatable to the generable public in aesthetically pleasing and enjoyable ways.

Focusing on Public Perspectives, Diligently Improving the Public Art Domain

Yang pays extra attention to public feedbacks and frequently checks which spots at the Suao Service Area are popular on social media, in order to review how The Illuminating Flow is received by the public. He was especially moved by a post that described the artwork as a time machine. The artist also finds the journey through the 12.9 kilometer-long Hsuehshan Tunnel a good opportunity to gather his thoughts and review the artwork. He installed round car lights on The Illuminating Flow's circular structure, with the intention of providing a literal direction for those on the road and also as a symbolic spiritual guidance. The gentle and subtle expression also conveys the emotions of a homebound journey.

More than just a creator of public art, Yang also serves on a public art review committee. "The success of a project is dictated by the artist's level of dedication. To include 'public participation' as a part of the review process is intended to emphasize that artists can't see this as a one-person show and should use art and take action to interact with others." Yang asserts that he will continue to devote himself in this pursuit and looks forward to seeing how public art is perceived by different communities in society.

The Illuminating Flow

羅萬照 國立藝術學院（國立臺北藝術大學）美術系畢業，獲法國 ESA 建築學院建築師文憑，現任養空間生活提案工作室負責人、宜蘭縣公共藝術委員會審議委員。

羅萬照

《平安回家》，轉生挖雪隧機械獸

雪山隧道之完工被譽為「世界工程奇蹟」，為紀念血淚開挖史，國道五號宜
蘭段公共藝術設置計畫由宜蘭藝術家羅萬照以導坑 TBM（全斷面隧道鑽掘
機）為素材，創作藝術即史料的《平安回家》。

撰文／蔡舒湉　攝影／張家瑋　翻譯／廖蕙芬　圖片提供／羅萬照

2019 年高速公路局推動將雪隧導坑
TBM 公共藝術化，建築師兼藝術家羅萬照
經邀請比件，著手改造這隻沉睡的機械巨
獸。面對文物，羅萬照總是投以溫柔的目
光，他說：「就像開一扇門，有人是拿了
鑰匙用完即丟，有人是留下工具作為紀念。
這臺 TBM 不是最貴，也不是最大，它的重
要價值是鑿挖雪隧、保留無數人的記憶，
我們有責任告訴後代它扮演的角色。」

塑造地景　尊重歷史脈絡

國道 5 號頭城交流道高架橋下，有直
徑約五公尺、長達 100 公尺的圓柱狀機械
裝置，此乃羅萬照重新組裝挖掘雪隧導坑
的 TBM，他悉心剝除機器表面浮鏽，再增
設兩排燈光設計。作品位置也講究，規劃
在當年它戮力效勞的位置，亦即挖導坑的
軸線上，從而帶出後方的主角──雪隧；

而 TBM 的機頭面朝宜蘭，背後亦有謹慎的
安排。羅萬照說：「雪隧一直存在，只是
你沒有注意到而已。我希望藉由作品提出
檢討，探問我們在現代化的過程是否夠珍
惜土地環境，以及恰當地運用能源。」他
以尊重歷史的心態完成《平安回家》，公
共藝術的說明牌則特地規劃在小斜坡上，
用意是引導每個駐足閱讀文字的人，都能
謙卑地向挖雪隧的工程英雄們致敬，見證
在最便捷的交通背後是最艱鉅的工程。

雪山隧道的工程困難度為國內史上首
見，1991 年動工時，引進挖掘英法海峽
的 TBM 工法，歷經漫長的 15 年歲月才正
式通車。總長 12.9 公里，也意味著全臺灣
最長的隧道震撼誕生。導坑 TBM 在功成身
退後，零件經拆解堆放在國道 5 號頭城高
架橋下，原本是走向報廢的命運，所幸宜
蘭縣政府爭取留存為「臺灣最大的工程文

物」，並規劃雪山隧道文物館。2014 年，鑽頭先是在武荖坑風景區於宜蘭綠色博覽會場展示，之後轉化為公共藝術品。

如實還原　刻劃生命狀態

羅萬照為陽剛的機器注入溫柔的土地關懷，並透過材質處理、導覽員與周邊環境規劃喚起與地方的對話。規劃初期，他先是前往零件堆放處「研究背後的心理狀態」，盯著一團凌亂，他無意過度淨化、美化，而是以忠實組裝、如實還原為原則，藝術團隊中還安插一位當時開挖隧道的工班。在組裝過程，被切割的結構會設法彌補，但不打磨表面；鏽蝕者則剝除浮鏽，表面施以鏽變漆，保有歲月沖刷的時間感。他感性地說：「機械使用到一個階段就會滲油，這也是它生命的一部分。」

另一方面，羅萬照也規劃公共藝術與周圍環境的關係，同時附加功能性，例如爭取到一條行人專用道，供居民在散步過程遊賞公共藝術；抑或是在《平安回家》周遭策展，打造年輕藝術家的發表場域。他強調藝術的狀態是連動的，周邊措施沒有做好規劃，便無法成就公共藝術的高度。

銜接地方　居民續說傳奇

《平安回家》策劃許多民眾參與活動，獨具庶民慶祝色彩的「辦桌」是其一，羅萬照團隊在 40 桌流水席間銜接地方居民、爭取作品認同。在公共藝術開展期間，又邀請地方長輩擔任導覽員，讓居民切身體會推廣 TBM 背後的意義，而不是隔出一件高不可攀的藝術品。他笑著說，展期結束後，卸任的導覽員仍然每天報到，主動為異地遊客解說作品，表現出與有榮焉的自信感；也看過單車環島的騎士在附近搭帳篷小憩，代表作品具備親切感，充分融入環境關係，這些都是公共藝術埋下文化種子的鐵證。

「我們從老祖宗智慧得知，藝術是一種境界，不是一種職業。」羅萬照感慨正規訓練能夠培育出優秀的藝術家，但是鮮少能養成藝術大師。身兼宜蘭公共藝術審議委員，他關注公共性與藝術性兩大發展主幹，並主張要以更開放的態度迎接各種藝術品，莫以既定框架限制發揮。「我希望用作品帶出背後的歷史脈絡與文化意義。感謝雪隧英雄的努力，這條路不該被視為理所當然，臺灣的驕傲值得被流傳。」

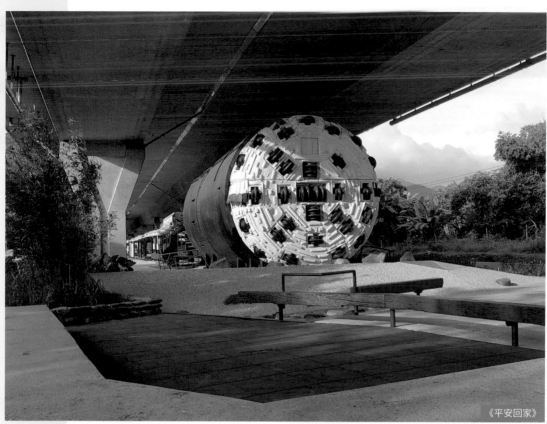

《平安回家》

藝術家與展場解說員

藝術家布展現場

A Carrier of History,
A Rebirth of the Hsuehshan Tunnel Mechanical Beast

The Hsuehshan Tunnel is touted as a world-class construction miracle, and to commemorate its extremely challenging tunnel excavation process, Yilan-based artist Lo Wan-Chao created A Safe Journey Home for the National Freeway No. 5 – Yilan Section Public Art Installation Project. The creation, an artwork and also a historical record, is composed of the "tunnel boring machine" (TBM) that was used during the tunnel excavation.

Written by **Shu-Tien Tsai** Photography by **Chia-Wei Chang** Translation by **Hui-Fen Liao** Images Courtesy of **Wan-Chao Lo**

Wan-Chao Lo

Wan-Chao Lo is an alumnus of the Department of Fine Arts, National Institute of the Arts (now Taipei National University of the Arts) and holds a diploma in architecture from École Spéciale d'Architecture (ESA), France. He is now the head of a lifestyle design firm and also a member of the Yilan County Public Art Review Committee.

The Freeway Bureau began initiating the idea of turning the TBM used to construct the Hsuehshan Tunnel into public art in 2019. Wan-Chao Lo, who is both an architect and an artist, then took on the task of transforming this giant dormant mechanical beast. "This TBM was a valuable part of the Hsuehshan Tunnel excavation and embodies the memories of countless people. We have the responsibility of telling future generations about the role that it once held," says Lo in a gentle and caring tone.

Shaping the Landscape with History Honored

Under the overpass of the Toucheng Interchange on the National Freeway No. 5 is a cylindrical mechanical installation that is about 5-meter in width and 100-meter in length. This reassembled TBM is the work of Wan-Chao Lo. He meticulously removed the rust spots on the machine and enhanced the work with two rows of lighting.

The positioning of the artwork is also well considered, which is related to where the machine was used during the construction. It is positioned along the route of the pilot tunnel excavation and then extends out to connect with the main subject

– the Hsuehshan Tunnel – in the back. The head of the TBM is pointing towards Yilan, and the back of the piece also consists of careful arrangements. Lo created this artwork, entitled A Safe Journey Home, with the mindset of honoring history.

We've learned from the wisdom of our ancestors that art is a frame of mind and not a profession.

The Hsuehshan Tunnel was the most daunting construction in the history of Taiwan. After successfully completing its mission, the TBM was taken apart, with the parts left under the Toucheng Interchange overpass. By transforming this machine into a public artwork, its fate of being discarded as scraps was completely altered.

In the early stage of the planning, Lo inspected the site where the parts were stockpiled. He had no intension of overly purifying or beautifying but had the vision of restoring it back to its original state. The project team also consisted of workers that had previously worked on the tunnel excavation. During the assembling process, parts that were previously cut were repaired, with the surface left unpolished. Rust spots were then removed, with rust converter applied on the surface and the imprints of time purposely preserved.

Connecting with the Local Area, Let the Legend Be Passed Down by the People

Many public participatory events were organized for A Safe Journey Home, and the festive folk custom of "traditional banquet" was one of them. The team led by Lo organized a 40-table banquet to connect with the local people and to raise their awareness for the artwork. The local residents were able to learn about the significance behind the TBM and to see the artwork as something that's not exclusive and unapproachable.

"We've learned from the wisdom of our ancestors that art is a frame of mind and not a profession." Lo, who also serves on the Yilan Public Art Review Committee, pays great attention to the two major developmental backbones of public art: "public-ness" and "artistic quality". He also advocates to welcome all kinds of art with an open mind and not to restrict creativity with conventional frameworks.

A Safe Journey Home

形塑高公局之自明性，嶼山工房的構築實驗

林聖峰主持的嶼山工房（Atelier Or）經手許多公共建設，並且屢屢在建築競賽中掄元，其作品注重回應環境關係，以及構築的系統性，從而凝聚出詩意的空間秩序。

撰文／蔡舒湉　攝影／張家瑋　翻譯／廖蕙芬　圖片提供／嶼山工房

2011 年林聖峰創立嶼山工房，以策展的實驗成果作為建築與景觀設計的出發點。他擔任 2018 實構築策展人時曾言，最重要的是呈現各種答案，並從差異中發現一致性，而這種梳理功夫也是創作高速公路局地景的絕妙手段。

漂浮地景　山河如織似錦

由嶼山工房操刀的「千里如織，山河似錦」共有三件作品，包含設置在第二辦公室門口的藝術棚架、位於第二辦公室右側與大門口間綠地的線形公共藝術，以及高公局公車亭。位於第二辦公室的行控中心是國道系統運作的中樞，透過智慧化監視及控制系統，負責行車安全管理、效率服務，及快速應變等業務。林聖峰認為原先第二辦公室入口很功能性、缺乏自明性。棚架設計一方面回應高速公路的環境關

係，表現速度感、引道、坡地、樹林等意象，一方面擷取高公局既有建築的 45 度切割特色，用作造型的基本語彙。恣肆開展的折線由大量形抗折板、尖角和耐候鋼構成懸浮地景，除了透露基地性格，也以這幅抽象山水提供遮陽蔽雨、停留休憩等機能，展現剛柔並濟之氣韻。

延續折板與耐候鋼的設計語彙，綠帶上的線形公共藝術亦試圖梳理人行、停車空間。設計以美人樹為焦點，牽引出虛實變化的折線，富節奏性地穿梭在蓊鬱多姿的植栽之間，夜間輔以景觀照明，活絡園區開放空間的多變表情。後來追加的公車亭改造，繼續沿用建立的鋼材與折線主題，考量基地周遭有跨越涵洞的人行道，改善動線和照明成為重要議題。三處公共藝術串聯出系統性，用輕盈俐落、融入環境的手法實踐開放空間中的特色意象。

林聖峰 嶼山 工房 Atelier Or 主持人，現職實踐大學建築設計學系專任副教授，美國 Cranbrook Academy of Art 建築研究所建築碩士，專長為建築設計、構築創作、建築創作。

林聖峰

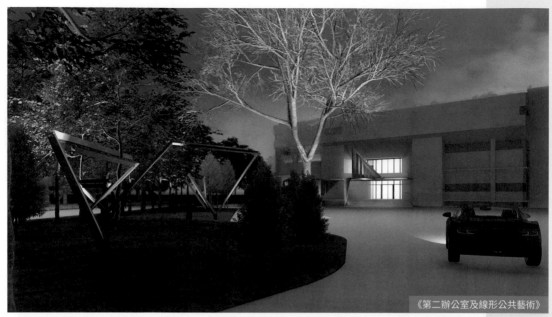

《第二辦公室及線形公共藝術》

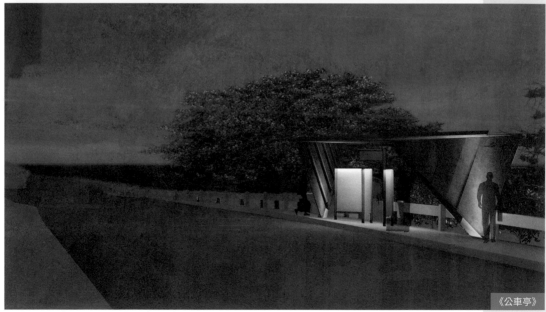

《公車亭》

反映風土 讓材質說話

　　耐候鋼是嶼山工房的招牌材質，這種含有錳、矽、鉻等元素的合金鋼會在短時間內快速鏽蝕，形成氧化保護層，並隨時間持續變化，質地樸實粗獷、自然復舊，在潮濕的臺灣易於維護保養。過去精采的應用如波光市集，為融入新竹漁港的自然環境，團隊打造延伸海面的大波浪屋頂，並多選擇耐候材質對應海邊氣候；新竹幸福廣場亦使用耐候鋼收邊、建隔柵，並交織弧形陶磚鋪面，用模矩化手段清晰地牽引流動曲線，以沉穩地的節奏回應護城河與歷史建築，再現古意盎然的地方記憶。

　　擁有工業設計轉往建築發展的學術背景，冶煉出林聖峰的講究細節、單元化與系統化思考。他分析，工業設計處理尺度、材料、色彩等細部關係，力求敏感細膩地透露；而建築是豐富的學門，需要集結許許多多跨領域專業人士。空間團隊在綜合辯證過程中，要悉心傾聽、嘗試理解各種不同意見，並守住自己的堅持。

創作者專注 策展者宏觀

　　林聖峰視建築是一種創作，必然要連結自己、環境和土地，並且在面對周遭地域環境、技術可能性與各種社會條件時，做出恰當的回應。身為創作者一定要專注，同時保有自己的信仰與愛好，不該一味妥協；身為策展人則必須抽離個人偏好，嘗試宏觀更大的視野。不變的是，兩者最後都要回歸自我，保有態度和觀點。

　　藝術是回應人生最柔軟的手段，串聯2022年將新落成的公車亭裝置藝術，泰管園區以環境劇場形式切入參與公共藝術，這場美學實驗在，國道第一個公車站高公局站即興演出。透過行動藝術啟發園區及用路人關注日常、察覺環境中變化，在互動表演中印證觀點無所不在。

　　「我相信不管是建築，還是環境創作，都是關於回應環境狀態。我習慣的創作手法是回到最初與環境對話，再從幾何出發演繹，用最精簡、盡可能是單一材料的結構，找到最恰當的答案。」站在教育者立場，林聖峰建議美感教育應豐富學生的感知經驗，並訓練做系統性美學想像，未來在做設計判斷時，才不會過度操作。「唯有凝聚共識，我們才能為城市找到更好的答案！」

Shaping the Freeway Bureau's Identity, Atelier Or and Its Tectonic Experiments

Atelier Or led by Lin Sheng-Feng has undertaken several public infrastructure projects and also often comes out triumphant in architecture competitions. The projects created by the firm pay attention to environmental correlations and systematic tectonics, seeking to bring together a sense of spatial order that also exudes poetic qualities.

Written by **Shu-Tien Tsai** Photography by **Chia-Wei Chang** Translation by **Hui-Fen Liao** Images Courtesy of **Atelier Or**

Sheng-Feng Lin

Director of Atelier Or. He holds a master's degree in architecture from Cranbrook Academy of Art in the United States and specializes in architectural design, tectonic art, and architectural art.

Sheng-Feng Lin founded Atelier Or in 2011, he once stated that it is of utmost importance to present various solutions and then to discover their shared commonalities from observing their differences. This kind of organizational skill is also a superb way to approach the Freeway Bureau's landscaping projects.

Floating Landscape, Embroidery-esque and Brocade-like Sceneries

Countless Embroidery-esque Miles, Great Brocade-like Landscape by Atelier Or is comprised of three artworks, including the linear-shaped public artwork installed on the green zone to the righthand side of the 2nd Office Building, the art scaffolding by the entrance of the office, and the Freeway Bureau bus shelter. According to Lin, the original entrance was quite utilitarian but not very identifiable. The design echoes with the sense of speed experienced on freeways and also shows other environmental connections related to access ramps, slopes, and trees. The project references the park's existing building's 45-degree slanted angle and uses lots of form-resistant folded plates, sharp angles, and weather-resistant steel structures to create aerodynamic contours. The resulting landscape feels like its floating, and the abstract setting highlights the site's unique features and also offers people a practical place to be shielded from weather elements

and to take a rest under.

The art scaffolding on the green zone distinguishes pedestrian and parking spaces, and the lighting design provides shifting rhythms and refractive lines at night that invigorate the landscape. Moreover, the bus

> Regardless of architecture or environmental art, I believe that it is important to pay attention and respond to the environmental conditions observed.

shelter includes a pedestrian walkway that connects and passes over a culvert, which improves the traffic flow and offers better lighting. With the extended use of the folded plates and weather-resistant steel structures that project modern qualities, a vivid impression is created in a simple and succinct manner. The three public artworks present a connected systematic quality, with notable features in this open public space realized through a light and precise approach that seeks to harmoniously become a part of the environment.

A Creator Should be Focused, A Curator Should be Broad-minded

Lin believes that architecture is a form of art, and connections must be formed between oneself, the environment, and the land, while also making appropriate responses towards the surrounding setting, technical possibilities, and various social conditions that may be encountered. A creator has to be focused and also stand by their own belief and preferences. However, a curator, on the other hand, has to detach from personal preferences and try to use a greater broad-minded perspective to see things. However, the one thing that remains unchanged is that, in the end, everyone should maintain who they are and stand by your perspectives and viewpoints.

"The creative practice that I prefer is to return back to the original starting point and engage in a dialogue with the environment. I then depart from a geometrical perspective, with refined and, whenever possible, structures created using a single material applied, in order to find the most suitable solution." Lin also believes that aesthetic education should enrich the perceptual experiences and train them to engage in systematic imaginations that focus on aestheticism. Only by forming a communal awareness can we find better answers for our city.

The 2nd Office Building

陳秋惠 circle 設計微誌創辦人。Art Center College of Design 平面設計科系畢業。作品曾獲美國 AIGA 年度書籍設計獎、Pele Award 雜誌編輯設計獎等獎項。

陳秋惠

洪震宇 自由作家、跨領域創意教學工作者。清華大學社會學碩士、政大社會系畢業。臺灣少數連結人文與商業的創作者與實踐者。曾獲選為《Shopping Design》2013 年度影響力人物。

洪震宇

張盈智 築遠工程顧問負責人。美國康乃爾大學結構工程研究所畢業。國際知名結構技師，被譽為建築界的骨科權威，代表作品有碧湖畔、台中市圓滿戶外劇場、高雄市立圖書總館等。

盈智

陳雅萱 詮識數位策略發展總監。中正大學電訊傳播研究所畢業，臺灣大學經濟學系博士班就讀中。曾任聯合報系媒體創新研發中心研究員，致力於應用科學化方法研究社群和數位廣告。

陳雅萱

工作坊育成灌溉，設計實驗美力上路

為了提升團隊的美學素養與設計思維，高速公路局特別舉辦「美的設計實驗室」系列工作坊，在進修與跨部門互動過程，源源不絕地將創意靈感融入建設之中。

撰文／蔡舒湉　翻譯／廖蕙芬　圖片提供／米花艸果

社會科學的泰斗拉斯威爾（Harold Lasswell）研究傳播行為，提出："Who says What in Which channel to Whom with What effect." 凸顯出發言者、內容、渠道、對象與效果等要素，而這 5W 也是美的設計實驗室工作坊的研究骨幹。

讓風格文字與色彩自己發聲

為了守護駕駛者的安全，高速公路上的交通標示系統、廣告宣傳看板與公共藝術特別注重不擾亂注意力。circle 設計微誌創辦人陳秋惠以「文字編排與色彩計畫」為主題，強調字體和色彩是文字編排與版面構成的兩大關鍵。「字體是有表情的，它反映內容的風格與情緒，即使是同色系的顏色，也會因為強度表現不同，產生不同的效果。」

透過文字編排可以增加視覺美感與易讀性。中、英文字體相互搭配時，要注意字體的粗細和字形的相似度，而紙本、數位等不同載體適合的字體也不盡相同。配色亦是一門不容小覷的功夫，陳秋惠介紹色彩概念、色彩養成及應用範疇，譬如可觀察大自然的四季演變，再轉化為用色靈感，啟發學員發揮創意，追求精采出色。

邏輯思考造就精準寫作

寫作是滿足讀者的服務業，而吸引人的秘訣是做到體貼又驚奇。跨領域專業的創意顧問洪震宇主講「邏輯思考與精準寫作」，他強調溝通者必需將複雜的事情變得簡單、有趣，並保有深度。要清楚自己的目標、策略與價值，才有能力與自信傳遞所思所想。他提出「一句話講完文章觀點」與「一分鐘講完寫作主題」的能力，如果無法精簡、清楚地說明，也代表寫作

者不夠深思熟慮。

富蘭克林寫作學習法主張模仿與改造，做法是拆解佳文的結構，再嘗試打散重組；魚骨寫作法則先提出結論，用好讀、好記又具體的一句話說明本質。正如機械錶最寶貴的是機心，梳理結構時要了解讀者最關心的議題與閱讀順序，並結合豐富的體驗說引人入勝的故事。精準提問、有效鋪排，文章會更具魅力！

數位行銷考驗自我掌握度

當許多人執著於粉絲數、按讚數，事實上互動率才是關鍵。陳雅萱主講「數位行銷」，她綜觀社群媒體現況與趨勢，有感數位行銷的受眾和做法都是多變的排列組合，主張要與時俱進地釐清觀念、學會新工具，並釐清自己的目的，掌握品牌價值、品牌個性、產品訴求。

社群平臺功能琳琅滿目，唯有選擇正確的互動方式和適當的合作對象，才能更有效地發揮價值。數位行銷最大好處是每個動作都有紀錄，市場調查的範圍與數據都更方便追蹤，然而也因為通路多、用戶紛雜與資訊破碎化，不再是容易曝光的時代。陳雅萱提醒，自我掌握地好（如製作好官網），會更優於社群行銷，這才是考

慮成本和未來的根本之道。

美的結構鞏固安全與永續

安全是思考結構的唯一考量嗎？「建築界的骨科權威」張盈智主講「結構之美」，他提問眾人對未來城市的想像，主張結構不僅是考慮建築本身的安全問題，同時也關乎比例、環境美感，尤其在處理國際共識環保議題時，評估要點也絕非材料本身能否回收而已。譬如鋼構與鋼筋混凝土哪個材料更環保呢？儘管鋼材可再製，但煉鋼廠同樣會對環境造成消耗，因此要看整體結構系統能否永續運作。

永續環保有 3R：Recycle、Reduction、Reuse，張盈智主張能高效率地利用材料、有高效率的結構系統，由此奠定美善環境的基礎。此外控制成本也是重要議題，例如想做出曲面，結構要盡量簡化，接近弧線是聰明的選擇。面對特殊設計時，也要思考未來機關面臨的維修管理成本。

張盈智在簡報上秀出「Design = Smart Solution」，定義設計是用聰明的方法解決問題。本系列工作坊同樣鼓勵同仁與時俱進，廣泛與各界締結更通暢的對話，在反思與學習過程持續進化，共創美力成長。

Workshops that Nurture and Empower, Design Experiments to Put Beauty and Strength on the Road

A workshop series, titled "Aesthetics Design Lab", is organized by The Freeway Bureau, with the objective of elevating the aesthetic competence and the design thinking of its teams, with advanced training and inter-departmental interactions facilitated, in order to encourage the incorporation of inspired creativities into infrastructural development.

Written by **Shu-Tien Tsai** Translation by **Hui-Fen Liao** Images Courtesy of **Flora Go**

Jessie Chen

Founder of Circle: A graphic design zine, Jessie Chen graduated from the Art Center College of Design with a degree in graphic design, and some of the awards she has won include AIGA Year in Design for book design and the Pele Award for magazine design.

Kevin Chang

Head of the Envision Engineering Consultants Co., Kevin Chang holds a master's degree in structural engineering from Cornell University. An internationally renowned structural engineer, some of Chang's iconic works include the Fulfillment Amphitheater in Taichung and the Kaohsiung Main Public Library.

In order to ensure driving safety, it is especially important to make sure that the traffic signs, billboards, and public art seen on freeways are not distracting for the drivers.

Express Yourself Through Stylized Words and Colors

Jessie Chen, founder of Circle: A graphic design zine, has chosen to focus on "Typography and Color" to emphasize that typeface and color are the two critical building blocks of typographical layout and composition. Typography can enhance a design's visual aesthetics and readability. Since color scheme also requires professional skill, Chen introduces color theory, understanding of color, and range of application to inspire the creativities of workshop participants.

Precise Writing Through Logical Thinking

The theme of the workshop led by Frank Hung, a transdisciplinary creative consultant, is "Logical Thinking and Precise Writing", where emphasis is placed on the communicator's ability to simply and captivatingly convey something that's complex, while also maintaining the subject matter's scope of depth. Hung mentions the ability to "sum up an essay using one sentence" and to "convey the

subject of your writing in one minute". When a writer hasn't thought through something, they won't able to succinctly and clearly explain it.

A typeface projects a certain kind of expression; it reflects the style and the emotions of the content presented.

Digital Marketing, A Test on Self-efficacy

While many may obsess over the number of followers and likes on social media, the truth is "engagement rate" is much more important. In the workshop named "Digital Marketing", Sandra Chen advocates that people's viewpoints need to keep up with the times and new tools should be learned. Furthermore, a specific value can only be effectively exerted through understanding your objective and having a firm grasp of your brand value, brand personality, and product appeal.

Beautiful Structure Ensures Safety and Sustainability

Is safety the only thing to consider when it comes to structure? Kevin Chang, who is dubbed the "Orthopedic Authority in Architecture", leads the workshop on "The Beauty of Structure", where he emphasizes that structure is not only just about architectural safety, but also encompasses factors such as proportion and environmental aesthetics. When handling international environmental issues, the assessment entails more than whether or not the materials used are recyclable. It is more important to evaluate the sustainable operation of the overall structural system. Recycle, Reduce, and Reuse are the "3Rs" of sustainable environmental conservation. Chang advocates efficient use of materials and efficient structural systems, which can set the foundation for a better environment.

"Design = Smart Solution" is shown on the presentation given by Chang, which indicates that design is using smart solution to solve a given problem. The objective of this workshop series also seeks to encourage the team members to keep up with the times and to engage in more dialogues with people from other fields. Continual transformatoin and progession can be made through reflection and learning, and we can collectively improve in ways that are beautiful and poweful.

Frank Hung

A freelance writer and a specialist in transdisciplinary creative education, Frank Hung holds a bachelor's degree in sociology from the National Chengchi University and a master's degree also in sociology from Tsinghua University. He was listed by Shopping Design as one of the most influential people in 2013.

Sandra Chen

OMNInsight's strategic development director, Sandra Chen holds a master's degree in communication from the National Chung Cheng University, and is currently a Ph.D. student in economics at the National Taiwan University. She has previously worked as a research specialist at the Media Innovation Xenter of United Daily News.

藝術策劃人的使命，推動臺灣公共藝術前行

陳惠婷與劉瑞如兩位資深藝術策劃人，可以說是與臺灣公共藝術
一起成長的業界先驅，她們從策劃、執行、代辦與檢討不同角度
切入討論公共藝術，在實踐過程中促成產業人士共同成長。

撰文／蔡舒湉　攝影／張家瑋　翻譯／廖蕙芬　圖片提供／交通部高速公路局

「國內辦過很多次國際研討會，各國專家一致認同臺灣的公共藝術是最多元的，相較於國外，科技藝術特別多。」蔚龍藝術經理劉瑞如曾任職文建會，深諳政府希望所有媒材都能被視為公共藝術，然而對高速公路局而言，設置公共藝術的首要考量卻比任何單位更加重視安全，這點她與喜恩文化藝術創辦人陳惠婷英雄所見略同。

安全為最高準則　藝術家最大的挑戰

立法院於 1992 年通過《文化藝術獎助條例》，規定「公有建築物所有人，應設置藝術品，美化建築物與環境，且其價值不得少於該建築物造價百分之一。」而建築工程費的百分之一也必須用於設置公共藝術品。

劉瑞如發現，公共藝術的材料與創作模式 30 年來持續不斷地改變，藝術家對媒材的掌握度也愈來愈高。但對於高公局而言，公共藝術絕對不能影響行車安全。因此當文化部推廣 5G 應用，譬如讓觀眾走進〈清明上河圖〉，這類型高互動、大面積、多細節特質的公共藝術，想當然並不適用於車水馬龍的高速公路上，反倒是更適合在盡情停留、放鬆的服務區中做精緻的安排。她說：「高公局的安全規則最為嚴格，藝術家最大的挑戰也是安全性，作品絕對不能因為反光、閃爍等因素影響駕駛人。」

1992 年，陳惠婷自美國學成歸國後，便協助文建會（今文化部）擬定「公共藝術執行相關法規」，她研究國外高速公路上的公共藝術法規，發現強調作品必須以安全作為首要考量，不得影響高速公路的結構體、讓駕駛人分心、誤導交通號誌，或是危及行人道路安全；藝術表達的內容形式，則為社會大眾所接受，作品外觀能

陳惠婷　喜恩文化藝術有限公司創辦人，公司專門策劃公共藝術作品設置、執行民眾參與活動與講習，並提供公私部門藝術顧問服務。

陳惠婷

以色列藝術家大衛葛斯坦（David Gerstein）的作品

與周遭環境搭配，此外也講究耐久性、抵抗各樣無心的破壞，並考量後續、維護保養作業。「看似雞毛蒜皮的小事，其實都是魔鬼中的細節。高速公路上以功能性為優先，藝術是附加價值。」

從多元視角出發 延伸藝術價值的推手

畢業於淡江建築所及美國科羅拉多州立大學都市設計研究所的陳惠婷，曾任財團法人台北市開放空間文教基金會執行長12年，並創辦《公共藝術簡訊》雜誌。建築出身的她，從空間角度出發，基金會工作期間，舉辦許多智庫或民眾參與座談會，研究各國的做法，將可取之處應用在公共藝術示範案上。她亦擔任過審議委員（公共藝術的設置計畫書必須經過審議會通過才可以開始徵選作品），並以公共藝術審議委員的角度，時常坐車檢視高速公路沿線的公共藝術，「有發現作品嗎？」、「合適嗎？」、「喜歡嗎？」、「需要修復嗎？」這些都是基本檢討的議題。

公部門興辦機關依法推動設置公共藝術時，常不知從何做起，因而有代辦單位的興起，協助機關撰寫公共藝術設置計畫書，擬定公共藝術徵選簡章等，並擔任專案管理的角色。此外，公共藝術提案過程相當繁瑣，陳惠婷觀察到藝術家通常將創作重心放在發想造型，較少思及環境心理學，或是藝術品與人的關係；多半不擅長面對委員提問安全及管理問題，因而有藝術家主動尋求與陳惠婷合作提案。「代辦的工作，在徵選簡章是寫目標和理想，但是來投標的藝術家不一定可以適切地回應，所以我對做策劃更有興趣，希望能按照自己的理想如實履行。」她也是從代辦開始做起，後來逐漸轉為策劃人。2005年，成立喜恩文化藝術公司，業務項目包括：法規研究、設置後評估檢討、專案策畫、行政代辦與民眾參與及藝術教育推廣行銷等活動。

劉瑞如則是畢業於中國文化大學市政學系，2002年與夥伴共同成立蔚龍藝術，擔任經理一職。曾在文建會、台北市開放空間文教基金會工作，有著公家機構、私人企業與非營利單位的經驗，讓她能從多元視角深耕公共藝術，練就一身藝術行政的好功夫，「我最有興趣的是研究如何落實、發散、推廣文化政策，影響一般民眾。」在這過程中發現，能發揮文化影響力是自己熱情所在。

代辦單位主要任務是落實執行小組的意志。劉瑞如以中壢服務區為例，在重新修建期間，蔚龍藝術團隊協助確認設置地點及巡查工地。對於公共藝術在服務區的設置方案，她認為民眾在服務區停留的時

建築和都市計畫是城市的身體骨幹，公共藝術猶如靈魂。

劉瑞如

劉瑞如 蔚龍藝術有限公司經理，公司專職藝術行政及經紀，規劃公共藝術、藝文展覽和設計商品，並協助國際宣傳，徵件及海外招商活動。

劉瑞如

問不長，設置在公路上的藝術，被注意到的機會又更小，這樣的參觀動線難以規劃，因此委員會傾向挑選讓最多人欣賞的位置，並突出地方代表性的作品。由陳惠婷策劃，結合深耕桃園多年的公共藝術家姜憲明和陳麗杏的作品雀屏中選，帶出桃園蓮花與鵝產業特色，獲得許多民眾喜愛。

藝術介入空間 協奏質感與美感

高速公路上首重安全性，但在服務區的公共藝術卻比其他單位講求更高程度的休憩性質。陳惠婷說，不同單位、民眾在場域的停留時間，都會影響選取作品的方向與內涵，像是司法院、國防部、衛福部、稅務局等公家機關，往往更著重藉由公共藝術彰顯出機關的威嚴形象、重要使命與高度精神性；又如醫院，民眾經常花上漫長的時間排隊掛號、就診或領藥，能與作品相遇的機會、停留的時間自然也比較長。除此之外，飽受身心煎熬的病人也比一般大眾更需要溫暖的鼓勵，公共藝術取向則會以訴求陪伴與慰藉為主。

建築人出身的陳惠婷審視公共藝術的重點擺在藝術作品與空間的對話，建築和都市計畫是城市的身體骨幹，而公共藝術猶如城市靈魂。「理想的城市是可以步行其中，像是波士頓，城市裡散發著豐富的

訊息，置身其中可以與之做心靈對話，促進人際互動，提供歸屬感、藝術美感、趣味性和幽默感，而這些美好效應在公共藝術的推波助瀾下，可以加強作用力，同時為地方的精神特殊性加分。」

劉瑞如則對公共藝術的任務抱持相對純粹的觀點，「基本上，公共藝術的功能不是活絡地方，而是增加一地的質感，如果能讓經過的人感受到美，那就算是成功了。」藝術作品能否被欣賞、喜歡，或者是被辨識、解讀是兩種議題。她建議，大家面對藝術不必要產生心理壓力，「其實公共藝術是非常自由的，要怎麼詮釋都可以。審美是透過公共藝術培養的，欣賞沒有所謂懂不懂，而是願不願意。」

與公眾的對話
打造多元、健康的藝術環境

公共藝術比起純藝術更注重與人對話、與地交流，因此才有著是否能被大眾欣賞、解讀的討論，也放大檢視藝術家的功力。陳惠婷認為社會固然要養成購買、典藏藝術品的觀念，而藝術家也要禁得起徵選委員和市場的考驗，如此方能營造多樣化、健康的藝術欣賞環境。

「公部門的公共藝術跟美術館典藏作品是一樣的，都屬於公共資源，利用國家

的經費推動藝術文化，也都希望讓國人看見世界級的大作，其中也包括呈現國外藝術家的作品。隨著評審團、藝術執行小組成員背景不同，對作品的喜好會有顯著差異。」身為策劃人的她，致力開發新藝術家。「我認為信譽很重要，作品各方面表現出高水準，就更容易得獎。每個專案都是一個里程碑，好好做，以後會容易一些，抱持著『即使要多做一點，也要做好』的心態工作。」

藝術教育是必行之路，結合公共藝術的「民眾參與」就是機會教育的試煉場，常見做法如：舉辦攝影比賽、寫生活動、展覽、座談會、校園講習、手作工坊等。「找民眾參與要有技巧，關鍵是提供享受創作的成就感。」陳惠婷認為，參與有分對象、程度深淺、地點和階段性，而高速公路的對象為非特定人選，因此不一定能有很多人參與，更大的挑戰反而是讓非藝文族群提起參與的熱情。

親和但不盲從　鍛造藝術本質

近年來藝術裝置隨著民意，走向追求拍照打卡，陳惠婷提醒固然作品應與大眾親近，但仍得保有一定的水準與內涵。執行公共藝術專案若能有策展人角色進入，做整體規劃統籌，事先了解藝術家的風格、

概念是否與專案最契合，並藉由製作模擬圖進行充分溝通協調。最終，成就公共藝術整體感，最重要的是要選對藝術家、合適地點、符合精神和預算。

對藝術創作者而言，儘管競爭場上難免「強者愈強」、存在公共藝術常勝軍，但徵選委員對藝術的接受度也越來越寬廣，面對競案應抱持開放心態，應先尋求機會，譬如可以從小案子，甚至是臨時性的案子做起，有實際的成績後，慢慢累積經驗、建立聲譽。

論及趨勢變化，劉瑞如認為早期藝術家強調個人創作，經由推廣後，公共藝術形式走向多樣化。好比一張椅子，從前是排斥被坐，後來漸漸能夠接受讓人欣賞、觸摸作品。於意象性也有明顯差異，現在更注重彰顯地方內涵與居民感受。她最喜歡薩璨如與尼古拉・貝杜（Nicolas Bertoux）在石碇服務區創作的《時空行旅》系列，讚賞三件石雕群非常大氣，「好作品，讓人一看到就能心領神會！」

數十年來，高公局持續推動公共藝術，全面且多元化地在邊坡、交流道、服務區或是任何路口，漸進式地豐富美感體驗。劉瑞如認為高速公路的景觀不妨挑戰更多嘗試，「擁有這種進取的企圖心，與具備提升的能力，國民也會更有文化自信心。」

Art Curators' Mission to Drive the Advancement of Public Art in Taiwan

Experienced art curators, Virginia Hui-Ting Chen and Reylu Liu, are trailblazers whose careers have evolved alongside the development of public art in Taiwan. They examine and discuss public art through various perspectives that take into consideration public art planning, execution, commission, and review, and through their practical approach, they also oversee and inspire others working in the industry to progress, collectively.

Written by **Shu-Tien Tsai**　Photography by **Chia-Wei Chang**　Translation by **Hui-Fen Liao**　Images Courtesy of **Freeway Bureau, MOTC**

Reylu Liu

Reylu Liu works as a manager at the Blue Dragon Art Company, which specializes in art administration and management, public art and exhibition planning, and product design. Her company also provides services related to international promotion, call for entries, and international sales and marketing events.

Reylu Liu, manager of the Blue Dragon Art Company, has previously worked at Taiwan's Council for Cultural Affairs and thus understands that the government hopes to see various media applied in public art. On the other hand, the Freeway Bureau values the safety of public art installations more than any other departments, and this is something that she and Virginia Hui-Ting Chen, who is the founder of Shalom Arts Consulting, also agree with.

Safety Comes First, A Great Challenge for Artists

According to the Culture and Arts Reward Act passed by the Legislative Yuan in 1992: "Publicly-owned buildings shall be fitted with public artworks to beautify them and their surroundings. The value of such artworks shall not be less than one percent of the cost of construction of the buildings." Liu notes that the materials and creative methods of public art have continued to evolve throughout the last three decades, and artists are demonstrating a higher level of control over how art media are applied. For the Freeway Bureau, the one objective that the bureau has always stood by is that public art shall not interfere with traffic safety. "The

Freeway Bureau has very stringent safety protocols, and safety is also a great challenge for the artists to consider."

After Virginia Hui-Ting Chen returned to Taiwan from overseas, she assisted with the drafting of "Regulations Governing the Installation of Public Artwork", which prompted her to study other countries' regulations for public art by freeways, and she realized that safety must come first with this kind of public artwork. The artworks shall not affect the structure of the freeway, distract the drivers, cause confusion with traffic signs, or endanger the safety of road users. The themes and forms of the artworks should also be acceptable to the general public, and the appearances of the artworks should also coordinate with their surroundings. Furthermore, attention should also be placed on durability, abilities to withstand different unintentional damages, and maintenance and aftercare.

Departing from Diverse Perspectives,
Driving Force Behind Augmenting Art's Value

Virginia Hui-Ting Chen holds a degree in architecture from Tamkang University and had previously served for 12 years as director of the Foundation for Research on Open Space, Taipei. She also founded the periodical, Public Art Newsletter. Referencing her background in architecture, she notices that artists tend to focus on stylistic aspects and place less emphasis on environmental psychology or the relationship between a given artwork and people. Most of them are also not good at answering committee members' questions about safety and management; this is why companies that assist artists with drafting their project proposals have entered the scene. Chen started off as a commission agent and gradually transitioned into a curator, followed by founding the company, Shalom Arts Consulting, in 2005.

Reylu Liu, on the other hand, holds a degree in urban planning and politics from the Chinese Culture University and co-founded the Blue Dragon Art Company

Architecture and urban planning should be thought of as a city's body and bones, and public art is its soul.

Virginia Hui-Ting Chen

Chen Hui-Ting is the founder of Shalom Arts Consulting, Inc., which specializes in public art installation planning and organizing public participatory events and seminars. The company also provides services as a commission agent for public art projects.

in 2002, where she serves as manager. Having previously worked at the Council for Cultural Affairs and the Foundation for Research on Open Space, Liu has experiences working with public and private sectors and also non-profit organizations, which allows her to work with public art in profound and diverse ways. Having acquired exceptional art administration abilities from her experiences, Liu explains, "What I am most interested in is how to implement, extend, and promote cultural policies and to have an impact on the general public." Throughout this process, she has discovered that being able to generate cultural influence is what she's most passionate about.

Incorporating Art into Spaces with Quality and Aesthetics Harmoniously Blended

Although safety comes first when it comes to the freeway, however, public artworks in freeway service areas also demand a higher level of leisurely quality compared to other places. Chen explains the amount of time that different groups or individuals would spend in a service area has direct correlation on the kind of artworks that are selected for the space. She thinks public art should focus on sparking interactions between the given space and the surrounding city or town, and architecture and urban planning should be thought of as a city's body and bones, and public art is its soul.

Reylu Liu, on the other hand, holds a relatively simple view on the objective of public art, which reflects on the different issues involved when it comes to whether an artwork can be appreciated and liked, or whether it can be recognized and understood. Liu believes that "public art is very free. People can interpret it in any way they like. Aesthetic ability can be cultivated through public art, and art appreciation is not about whether you understand it or not; it is about your willingness to embrace it."

Interacting with the Public to Create Diverse and Healthy Art Environment

Compared to fine art, public art tends to focus more on interacting with people and the land it's on. Chen believes that the concept of procuring and collecting art should be established in a society, and artists also need to have the abilities

> Compared to fine art, public art tends to focus more on interacting with people and the land it's on.

to respond to the inquiries and tests from project selection committees and the market, which can then lead to the development of a diverse and healthy environment for art appreciation. Art education is also absolutely crucial, and teachable moments are able to be offered at public participatory activities designed in conjunction with public art. There isn't a specific target audience for freeway projects; therefore, it is not necessary to aim for a big turnout, because the greater challenge lies in encouraging the participation of people who usually don't pay attention to art.

Refining the Essence of Art by Being Approachable Without Blindly Following

In recent years, art installations have becoming more "Instagrammable", in order to meet popular trends. Chen cautions that although art should be approachable for the general public, it should, nevertheless, maintain a certain level of standards and substance. On the topic of changing trends, Liu thinks that earlier artists paid more attention to personal creative expressions, but after further advocacy and promotion, public art is now seen in a diverse range of formats. There are also obvious differences in the impression they convey, with more emphasis now placed on highlighting regional connotations and sentiments of local residents. Throughout the last few decades, the Freeway Bureau has been persistently promoting public art, and the effort has gradually led to a rich array of comprehensive and diverse aesthetic experiences seen on slopes, interchanges, freeway service areas, and on many roads.

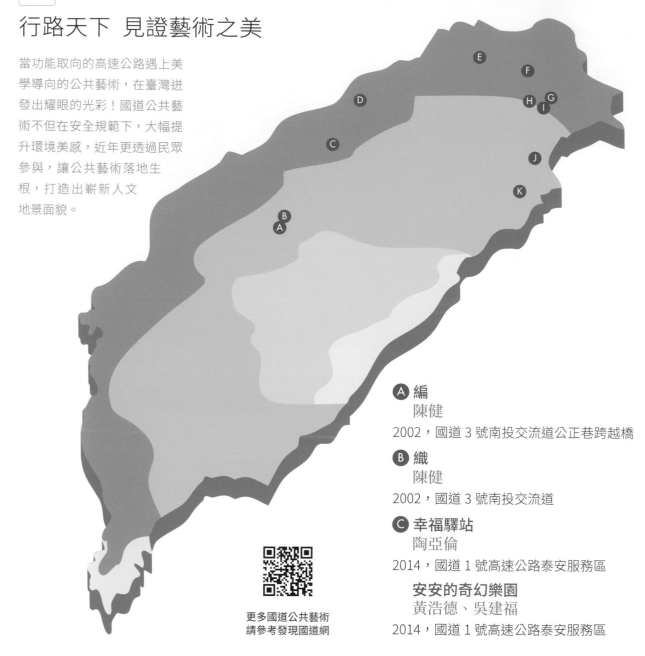

行路天下 見證藝術之美

當功能取向的高速公路遇上美學導向的公共藝術，在臺灣迸發出耀眼的光彩！國道公共藝術不但在安全規範下，大幅提升環境美感，近年更透過民眾參與，讓公共藝術落地生根，打造出嶄新人文地景面貌。

更多國道公共藝術
請參考發現國道網

A 編
陳健
2002，國道 3 號南投交流道公正巷跨越橋

B 織
陳健
2002，國道 3 號南投交流道

C 幸福驛站
陶亞倫
2014，國道 1 號高速公路泰安服務區

安安的奇幻樂園
黃浩德、吳建福
2014，國道 1 號高速公路泰安服務區

Ⓓ 美麗西湖
　　賴純純
2003，國道 3 號西湖服務區

Ⓗ 光陰隧道
　　薩璨如 & 尼古拉・貝杜
2000，國道 5 號高速公路石碇服務區庭園

Ⓘ 大地脈動
　　薩璨如 & 尼古拉・貝杜
2000，國道 5 號高速公路石碇交流道綠帶

Ⓙ 平安回家
　　羅萬照
2020，國道 5 號頭城交流道橋下

Ⓚ 流動的光河
　　楊尊智
2020，國道 5 號蘇澳服務區

Ⓔ 清逸蓮香、甜蜜滋味
　　姜憲明、陳麗杏
2017，國道 1 號高速公路中壢服務區

**　桐雪客居**
　　鄧惠芬
2017，國道 1 號高速公路中壢服務區

Ⓕ 行車動畫 如意與潮
　　胡復金
2001，國道 3 號汐止系統交流道

Ⓖ 時空漂鳥
　　薩璨如 & 尼古拉・貝杜
2000，國道 5 號高速公路石碇服務區

參考書目

❶《國道高速公路公共藝術及景觀設施》；
　　交通部台灣區高速公路局；1993 年 4 月
❷《大道之行─中山高速公路建設人員口述印記》；
　　交通部台灣區高速公路局；2017 年 6 月
❸《遊走兩岸公共藝術》；行政院文化建設委員會；
　　1994 年 6 月
❹《藝起飛─桃園機場第一航廈 公共藝術專書》；
　　桃園國際機場股份有限公司；2016 年 11 月
❺《繼往開來 感恩上路 中山高速公路發展全紀錄》；
　　交通部高速公路局北區養護工程分局；2010 年 6 月
❻《縱橫千里 臺灣高速公路 50 年》；
　　交通部高速公路局；2010 年 5 月
❼《島嶼的脈動 高速公路局 50 年誌 1》；
　　交通部高速公路局；2010 年 5 月
❽《島嶼的脈動 高速公路局 50 年誌 2》；
　　交通部高速公路局；2010 年 5 月
❾《建築師》期刊 --〈人與環境的互動關係 -- 建築師
　　「可以」創作公共藝術〉；陳健、蔡淑瑩；中華民國
　　建築師公會全國聯合會；2002 年 11 月

國道地景 × 公共藝術

流動的 THE FLOWING VIEWS
風景

A Road Trip
with Memories of
Time

國 家 圖 書 館 出 版 品 預 行 編 目 (CIP) 資 料

流動的風景：一趟充滿時代記憶的公路之旅 = The
flowing views : a road trip with memories of time /
蔡舒湉撰文 . -- 初版 . -- [新北市] : 交通部高速公路
局 , 民 112.02
　　面；　公分
ISBN 978-986-531-464-4(精裝)
1.CST: 公共藝術 2.CST: 地景藝術 3.CST: 作品集
920　　　　　　　　　　　　　　112000484

發行人｜趙興華
發行所｜交通部高速公路局
編輯委員｜陳振輝、張正仁、彭文惠、游安君
　　　　　　褚瑞基、熊鵬翔、劉法親（以姓名筆劃排序）
編輯團隊｜曾玉霞、曾兆璿、侯采彤、許玲維、蔚龍藝術有限公司

藝術家｜尼古拉・貝杜、吳建福、胡復金、姜憲明、陶亞倫
　　　　　陳健、陳麗杏、黃浩德、楊尊智、鄧惠芬、賴純純
　　　　　薩璨如、羅萬照（以姓名筆劃排序）
ISBN｜978-986-531-464-4
出版日期｜中華民國 112 年（2023）2 月初版
定價｜新台幣 350 元

設計製作｜商周編輯顧問股份有限公司
執行團隊｜董育君、廖珮君、許資旻、趙守予、張堃宇
撰文｜蔡舒湉
翻譯｜廖蕙芬
攝影｜張家瑋、蘇威銘
地址｜104 台北市中山區民生東路二段 141 號 6 樓
電話｜02-2505-6789
網址｜www.businessweekly.com.tw/bwc/